Beginner's Watercolour

Simple projects for artists

COLLINS & BROWN

This edition published in the United Kingdom in 2015 by
Collins & Brown
1 Gower Street
London
WC1E 6HD

An imprint of Pavilion Books Company Ltd

Distributed in the United States and Canada by Sterling Publishing Co, Inc.
1166 Avenue of the Americas, 17th floor, New York, NY 10036

ISBN 978-1-910231-06-7

A CIP catalogue record for this book is available from the British Library.

10 9 8 7 6 5 4 3 2 1

Reproduction by Rival Colour Ltd, UK
Printed and bound by 1010 Printing International Ltd, China

This book can be ordered direct from the publisher at www.pavilionbooks.com

Beginner's Watercolour

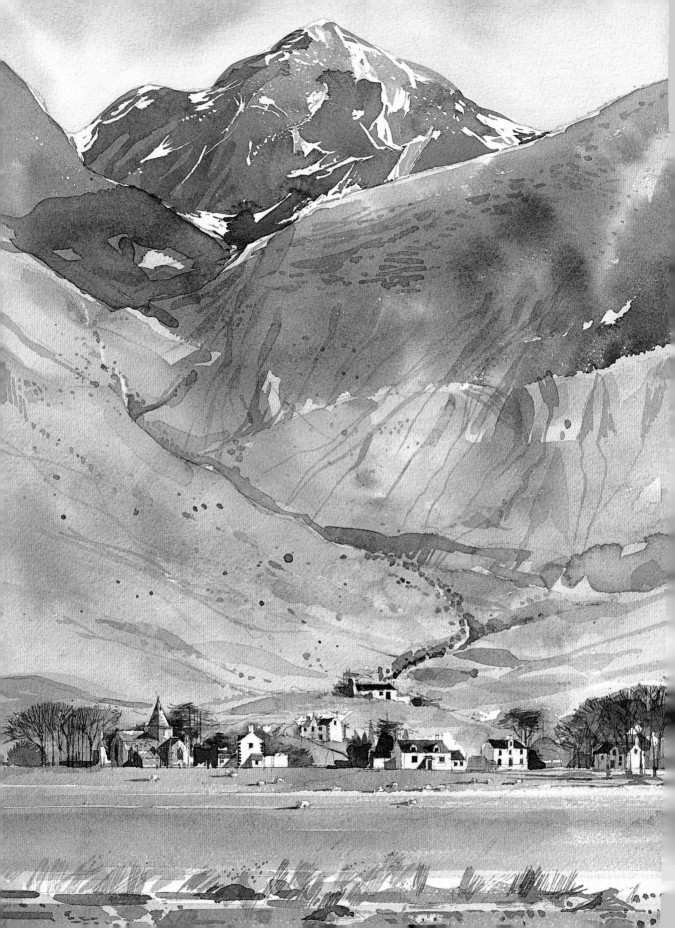

Contents

Introduction

Beginner's Watercolour was written with the aim of inspiring you to pick up a brush and a palette and learn to handle this most lovely and delicate of painting media.

Watercolour painting demands a fresh and spontaneous approach to the subject in order to show off the medium's wonderful translucency and delicacy of colour. This is a medium that is particularly well suited to capturing the quick changes of light, weather and mood that are essential factors in landscape painting. This book offers many different approaches to landscapes, from stormy seascapes to vibrant summer fields. We also branch out and show you the full the range of possibilities of subject, from portraits to buildings and intimate flower studies.

How to use this book

This book is divided into four chapters, helping you to gradually build up different techniques and approaches to painting.

Chapter 1 introduces washes, the broad, flat layers of colour that you lay down first to start building up an artwork. Working wet into wet and wet into dry are two technical approaches that will help you build up your artistic range, while lifting out and handling backruns offer two ways to help you cope with mistakes and turn them into features.

Chapter 2 introduces colour. Starting off with some basic colour theory, we then take in colour mixing, tone, and mixing palettes that will suit your given subject. It is easy to go overboard with buying paints when you are just starting watercolour painting, and there are certainly many tempting boxes and tubes on offer. However, it is a good discipline to know how to mix a wide range of tints and tones from just a small number of paint colours. Practising with a limited palette, or even with monochromatic studies, focusing on the interplay of light and shade in a subject, will be a valuable exercise.

Chapter 3 discusses texture and effects. These are some innovative ideas for you to introduce once you have a feel for the basics of watercolour painting. Try experimenting with resist media, sponging, drybrush and sgraffito, among other methods. Learn what sort of effects are best suited to a particular subject, and apply them with a light hand: it is possible get carried away with spattering and scratching and end up overpowering your artwork.

Chapter 4 gives a broad survey of the many different types of subject it is possible to capture in watercolours, with a particular emphasis on landscape features such as skies and water. The more you practise the more you will know what sort of subject most appeals to you, whether taking to the hills or coasts to capture stunning landscapes or staying in the studio to paint still lifes or portraits.

This book should inspire you to try an inspiring array of watercolour techniques to create the subjects that appeal to you most. The four main chapters deal with (clockwise from top left): understanding washes; using colour – including coloured papers; techniques, such as stippling; and subjects, such as buildings.

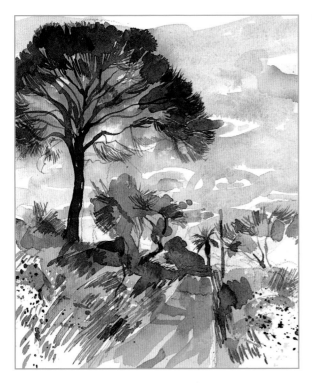

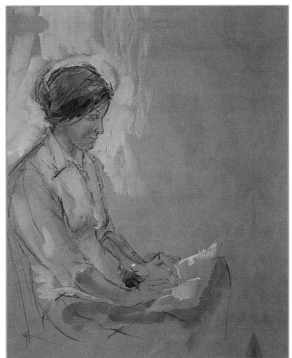

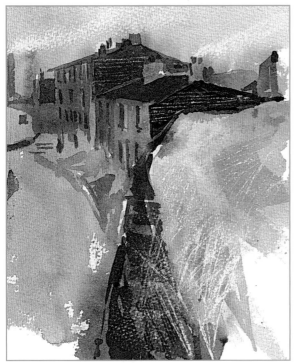

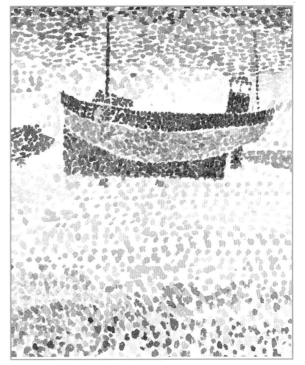

Getting started

Paper, paint, a brush and clean water are all the basics that you need to start painting watercolours, although there are other tools that you can introduce into your work to expand your repertoire of techniques.

Watercolour paints

Watercolour paint is available in the form of semi-moist pans, half pans and tubes. Pans are easier to use when working on smaller-scale works. Pans and half-pans that contain a block of semi-moist paint are practical, especially for working outdoors, as they are easy to transport and you can see the colours at a glance.

Tube colour is better if you are working on large paintings that require greater quantities of paint, as it is easier to mix a bigger wash. They dry out easily, so only buy large tubes of colours that you are sure to use a lot. It is possible to use small amounts from tubes, but you are more likely to waste paint this way.

Watercolour paint is sold in two standards: one for students and one for artists. Try to buy artist's quality paints, even if this means that you have less variety in your palette. It is a false economy to use cheaper and inferior materials.

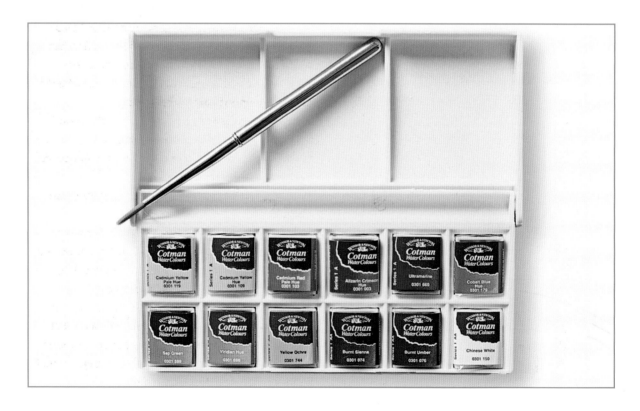

Palettes

Many watercolour boxes have built-in palettes for mixing, but these provide very little space. Although you can mix watercolours on the surface of the paper, artists usually mix paint on a separate palette. There are many varieties, available in ceramic, plastic and enamelled metal. You will need one with a deep well to mix a sufficient wash to cover a large area.

A round china dish with a lid enables you to cover and store paint, and it will keep the paint wet for longer than if it were exposed. A partitioned china palette is perfect for colour mixing. You can also improvise by mixing your colours on a china plate or saucer – but use a white plate, as coloured china will make it harder for you to judge your mixes accurately.

As watercolour is water soluble, palettes can easily be cleaned by washing them in the sink.

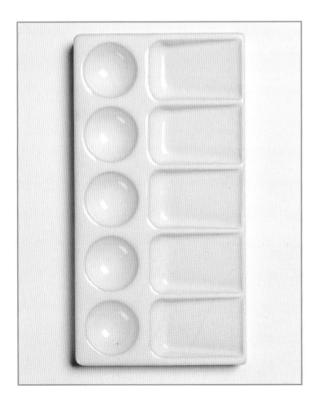

Brushes

Watercolour brushes can be made from synthetic polymer, nylon fibre or natural hair and bristle. Natural fibres are more expensive but will retain their shape and last well if looked after. Synthetic fibres are cheaper but will need to be replaced more regularly. A good compromise is a mixed-fibre brush, which benefits from the advantages of a natural brush but at a fraction of the cost.

Whichever type of brush you choose, it should hold its shape and point. A good brush should also hold a decent quantity of paint and have a firm but pleasant spring to it when applied to the paper.

Brush shape is of equal importance and there are three main options to choose from:
- Round brushes are most often used, and a good one can make a wide variety of marks.
- Flat brushes are chisel-shaped; they are sometimes known as one-stroke brushes.
- Mop or wash brushes are used for covering large areas.

More specialized brushes include fan brushes, which are designed to be used for fine feathering and delicate blending, and rigger or lettering brushes, which are used for fine lines (see page 10).

Generally, use the largest brush possible for the job. A good basic selection might include a no. 4 or no. 6 round brush for detail, a no. 10 or no. 12 round brush for blocking in washes over larger areas, a small flat brush and a medium-sized mop.

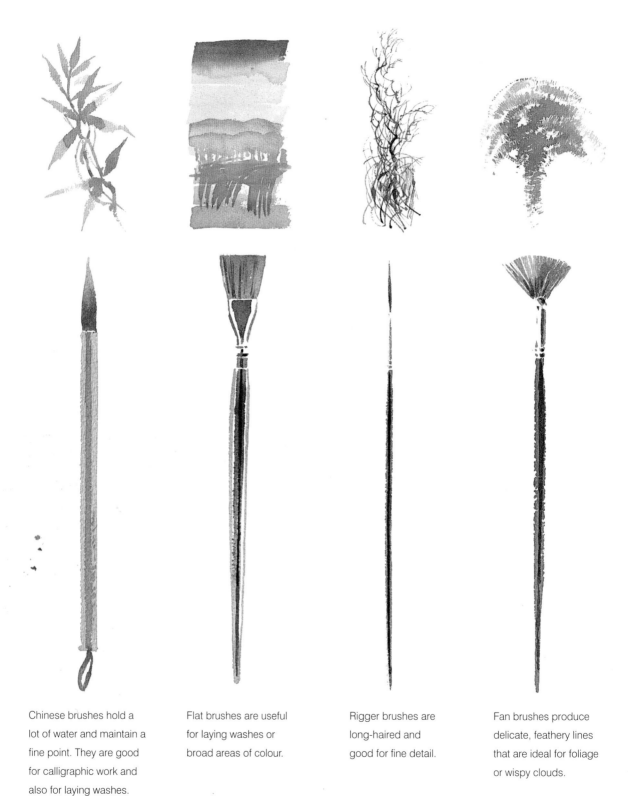

Chinese brushes hold a lot of water and maintain a fine point. They are good for calligraphic work and also for laying washes.

Flat brushes are useful for laying washes or broad areas of colour.

Rigger brushes are long-haired and good for fine detail.

Fan brushes produce delicate, feathery lines that are ideal for foliage or wispy clouds.

Uses of different brushes

Round brushes are the most common and frequently used watercolour brushes, but there is a great variety of shapes that you can call upon for special techniques or unusual effects. A flat brush is invaluable for laying broad washes of an even tone. For feathered effects, use a fan brush or a rigger, which allows you to paint in fine detail and is suitable for twigs and leaves. Chinese brushes are available in different sizes and are well suited to laying washes. They form perfect points, too, and are good for detail.

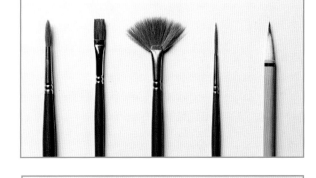

Caring for brushes

Any brush will be ruined if paint is allowed to dry on it, so it is important to clean brushes after use. Careful cleaning and storage will prolong the life of your brushes.

Always store brushes on their tips, otherwise you will break the hairs. Stand them upright in a glass or jar until you need them for your next painting session.

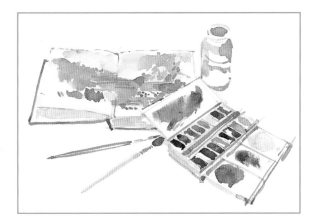

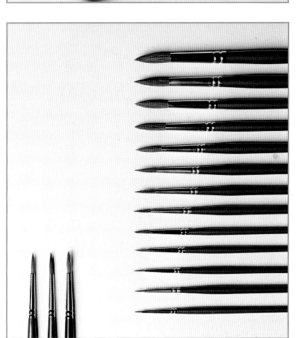

Paper

Watercolour papers are available in a range of weights from light (190gsm/90lb) through to heavy (640gsm/300lb).

There are three types of watercolour paper surface: hot-pressed (HP), cold-pressed (CP; also called 'not', as in 'not hot-pressed'), and rough.

- Hot-pressed papers are smooth with very little texture. They are often more heavily sized than other papers, which can cause washes to be repelled by the paper and settle in puddles.
- Cold-pressed papers fall between rough and hot-pressed and have a reasonable degree of texture.

- Rough papers have a pitted surface; they accept paint well and are usually capable of withstanding rough work and techniques such as scratching into the paper surface.

Paper is available in rolls, sheets and pads or blocks of different sizes. There are many different brands. It is worth experimenting with a few to find one that suits your painting style. For longevity, choose archival quality paper, preferably made from 100% cotton rag. Acid-free paper will not yellow over time. Watercolour paper cannot be reused, as the various ingredients of watercolour paint mean that the paint adheres permanently to the paper surface.

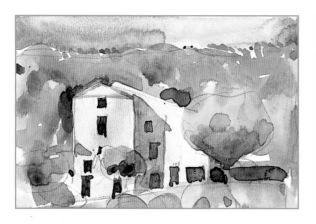

Hot-pressed paper has a smooth surface that enables you to paint in more detail.

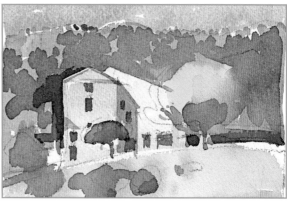

Cold-pressed paper is lightly textured and is a good general-purpose paper.

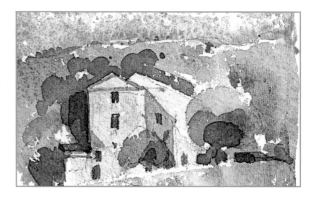

Rough paper has a natural, grainy surface that gives texture and adds sparkle to paintings.

Understanding paper weights

It may be confusing to be confronted with the many varieties of paper, together with the wide choice of weights. Papers are made and measured by the weight of a ream. This figure is expressed in grams (or pounds) per square meter (gsm). The standard paper weights are: 185gsm (90lb), 300gsm (140lb) and 640gsm (300lb). The heavier the weight, the thicker the paper. Lighter paper, for example 185gsm (90lb), will need to be stretched to prevent cockling (see page 14). The chart below describes the different types and weights of paper, their characteristics and suitability:

Type	Weight	Characteristics
Hot-pressed	185–640gsm (90–300lb)	Good for very wet washes, produces a flat, smooth finish, with slow absorption. Stretch all paper under 300gsm (140lb) before use.
Cold-pressed	185gsm (90lb), 300gsm (140lb)	Good for most watercolour techniques except sgraffito, gives an even finish with slight texture. You will need to stretch the paper before use.
Cold-pressed	640gsm (300lb)	Suitable for sgraffito and other techniques that require heavy handling, it is slightly textured, with slow absorption. No need to stretch paper.
Rough	185gsm (90lb), 300gsm (140lb)	Good for most techniques other than those requiring fine detail due to the pitted surface. It is quite absorbent. You will need to stretch the paper before use.
Rough	640gsm (300lb) and above	Good for vigorous techniques, such as sgraffito. It has a rough finish with slow absorption. You do not need to stretch the paper.

A wash applied to a heavy, rough paper will be absorbed slowly to dry with soft edges.

A wash applied to thin, smooth paper will cause the paper to cockle and the paint to dry in irregular pools and patches.

Stretching paper

To prevent them from cockling when a wash is applied, most lightweight papers (those under 300gsm/140lb) will need to be stretched before you start to paint. You will need a heavy board that will not bend or warp when water is applied. Cut your paper to the required size before you start and ensure that the board is larger than the paper. Use gummed tape rather than cellulose masking tape. Stretching paper is not a difficult task and it only requires a little pre-planning and patience. You should allow approximately 8–10 hours for the paper to dry out thoroughly before you apply your first wash of paint.

Materials

Heavy wooden board, sheet of watercolour paper, scissors, gummed paper tape, sponge, tray of water

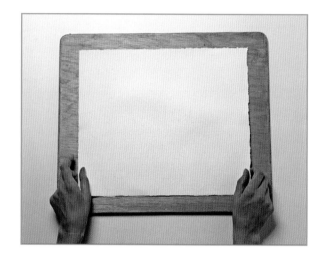

1 Cut the paper to the required size and lay it flat on the board. Leave enough margin around all sides for the paper tape.

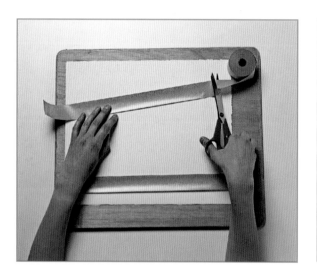

2 Cut four strips of gummed tape for each side of the piece of paper. Make the strips slightly longer than the paper.

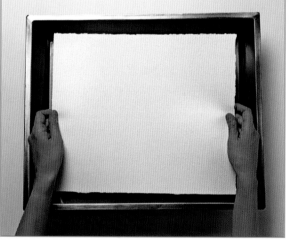

3 Lay the paper flat in a tray or sink of clean water and immerse for a few minutes. Make sure that it is evenly wet but not soaking. Lift it out and drain any excess water.

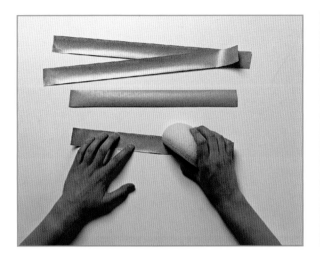

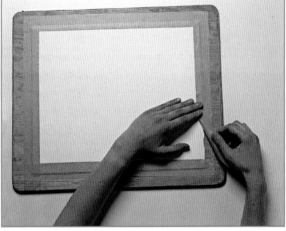

4 With a damp, clean sponge, moisten the adhesive side of the paper tape on a flat surface.

5 Lay the wet paper flat on the board, smoothing out any crinkles. Tape the paper to the board, starting with the long sides, ensuring that the paper is pulled flat and taut.

6 Lay the board flat and allow to dry completely, preferably overnight. Any creases will flatten out as the paper dries.

Other equipment

As you become more familiar with watercolour techniques, you may wish to branch out and start experimenting with introducing textural effects or resist methods to your artworks. Here are a few useful tools that will help expand your artistic repertoire.

Sponges

Sponges – both natural and synthetic – can be used to dampen areas of the paper and also to apply paint, creating an interesting mottled texture that cannot be achieved using a brush. A sponge is also invaluable for damping paper, lifting off and laying washes. Blotting paper or kitchen paper is essential for mopping up runs or lifting-off washes, while cotton buds are useful for lifting off in smaller, more detailed areas.

Masks

Masks are used to block out areas of your paper so that they remain free of paint. You can use masking tape or masking fluid; each offers its own distinct effect (see page 68).

Toothbrush

An old toothbrush makes an excellent tool for spattering paint over the paper (see page 74).

Improvized paint applicators

Branch out beyond the usual tools to create innovative textural effects: try pressing a piece of fabric, bubble wrap or scrunched-up plastic food wrap into wet paint to leave an interesting pattern on the surface, or dipping the edge of a piece of corrugated card into paint to create an irregular-shaped line.

Easels

A good easel can make painting easier and more enjoyable, allowing you to stand back and review your work. Most easels can be adjusted to different heights and can be angled to suit the medium in which you are working.

Portable easels are available if you like to paint outdoors, while studio easels are bigger and more solid and stable. Some can be folded away for storage, but the largest often become permanent fixtures in the studio. A table easel is ideal if you work on a small scale or if you have limited space. It sits on top of a table and can be folded away after use.

Equipment for working outdoors

One of the great joys of watercolour painting is that the equipment is lightweight and portable, and as the medium is so well suited to capturing the transient effects of weather, light and changing seasons, many watercolour artists delight in working outside.

The essential items for painting outside include a sketching stool or lighweight easel, paper or a sketchbook, HB, 2B or 3B pencils, an eraser, tubes or pans of watercolour paint, a good palette, a selection of three or four brushers (retractable brushes are available), a water container with spare water bottle, tissues, a sponge and something to carry the kit in. Other equipment may include a drawing board – some lightweight versions made from foam board are available, as are boards with carrying straps.

The two main problems with outdoor painting are wind and rain. Take some clips to hold down your work and a cover, such as a sheet of plastic or bubble wrap, to protect the work from rain drops.

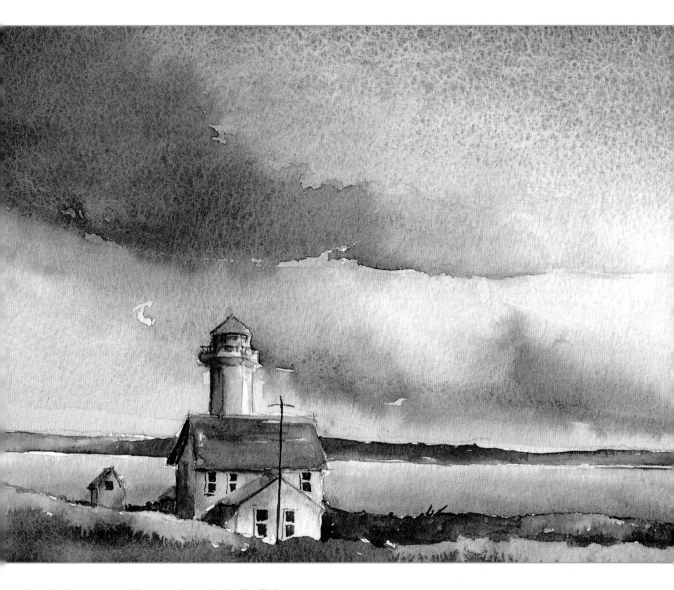

Investing in some portable watercolour painting kit will give you
the opportunity to capture beautiful scenes like this while you
are out in the open.

Other media

Because they are translucent and water-soluble, watercolour paints lend themselves to being used with other media. A useful place to start is with gouache and watercolour pencils.

Gouache

Gouache (sometimes known as 'body colour') is a water-based opaque paint. Pure watercolour has a transparency that negates the use of white and many purists will not use white in watercolour.

Gouache is available in tubes of colours or as Chinese white, which can be mixed with traditional watercolours to create opaque colour. It can be used for clouds, white sails, to describe the pattern of fur or feathers, or simply as a highlight in a sunlit scene. This is a medium that will be shown to advantage on a tinted or toned paper (see page 56).

Watercolour pencils

Watercolour pencils (or water-soluble pencils) are a very useful addition to your equipment. You can use them to draw or sketch the main elements of your composition, using hatching or shading to give tone and depth. These areas can then be blended on the paper with a damp brush or wetted finger with more control than traditional watercolour paint or washes. Alternatively, you can combine them with watercolour washes. Apply the pencil over a damp wash for a soft, feathered line or onto a dry wash for more precise detailing.

Blending can be achieved without wetting, but large areas or washes of colour are obviously difficult to produce. Watercolour pencils can be used on any paper surface, but for best results choose a cold- or hot-pressed paper.

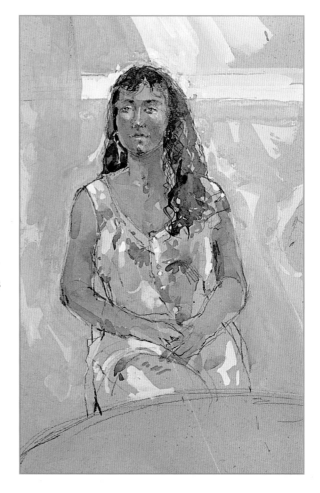

For this portrait study, the artist used white gouache to add highlights to the dress and blended this to give opacity to the skin tones.

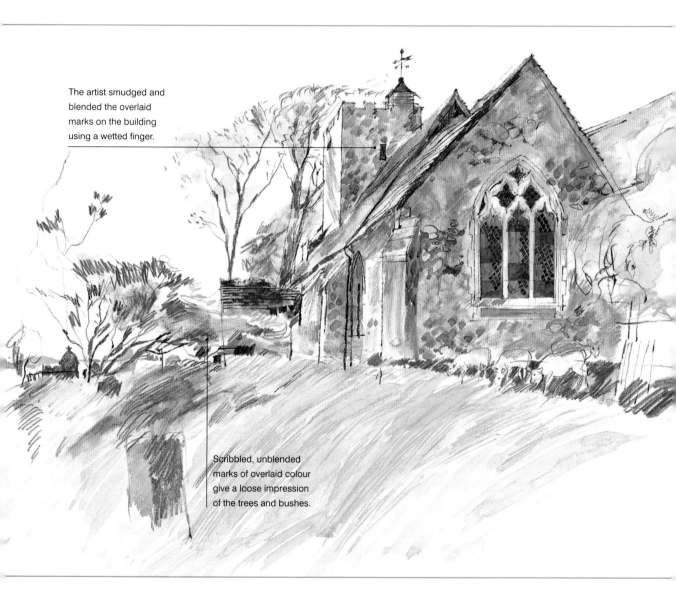

The artist smudged and blended the overlaid marks on the building using a wetted finger.

Scribbled, unblended marks of overlaid colour give a loose impression of the trees and bushes.

You can make detailed sketches or even finished paintings using watercolour pencils with a brush and supply of water. Here the artist combined dry pencil marks with wetted, blended marks to give the impression of the aged and weathered stonework on this church.

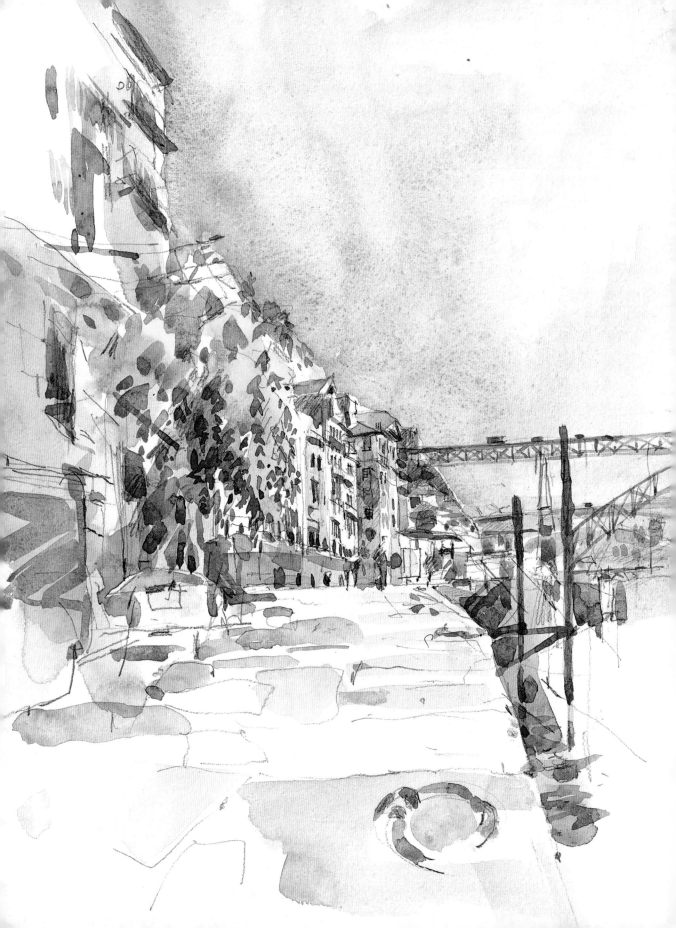

Understanding Washes

Watercolour paintings gain their particular characteristics from the subtle layering of washes and blends of colours. This chapter explores the principles behind mixing colours and laying simple washes, helping you to understand how to achieve a wide range of natural colours from a limited palette and lay the foundations for a successful painting.

Laying a flat wash

A flat wash is an even application of one colour that dries with little or no variation in the tone. It can be used as an underpainting or for toning the paper to provide a neutral midtone that unifies the image.

The secret to laying a successful flat wash is to work quickly and confidently, touching each area of the paper with just one stroke of paint. If you hesitate or repeat a stroke, the paint will not dry evenly. The fewer strokes you use, the more even the wash will be, so use a large mop brush if you want to cover the whole paper. To begin with, you may find it easier to dampen the paper with a brush or sponge.

 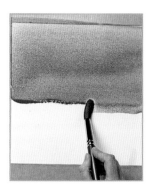

1 Load the brush with paint, tilt the board so that it is lying at a slight angle and lay the first stroke of paint across the top of the paper.

2 Work quickly backwards and forwards as shown, picking up fluid paint that gathers at the base of the previous stroke. Squeeze the fibres of the brush semi-dry and blot up any excess paint that has pooled at the bottom of the paper.

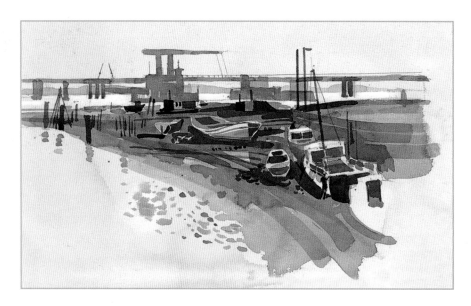

For this harbour scene, the artist first laid a soft, very pale, flat wash of raw sienna to unify the image and provide a warm overall background tone.

3 Allow the wash to dry naturally, with the board still tilted; if you lay it flat, paint will flow back and dry with a hard edge. Don't worry if the wash looks uneven when wet; the tone will even out and become lighter as it dries.

Laying a gradated wash

A gradated (or graduated) wash is applied in the same way as a flat wash, but rather than using the same flat, even colour, you lighten or darken the colour as you work.

Gradated washes are especially useful for painting skies and landscapes, where you may want to use subtle variations in tone to convey an impression of distance.

Start by damping the paper with clean water and a sponge, and mix a generous amount of wash.

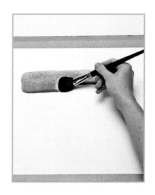

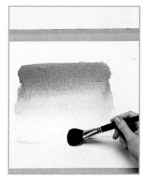

1 As with a flat wash, lightly lay the first stroke of colour across the paper.

2 Work quickly backwards and forwards, down the paper. To make the wash lighter as you work down the paper, when the paint runs thin, add more water to the brush rather than more paint.

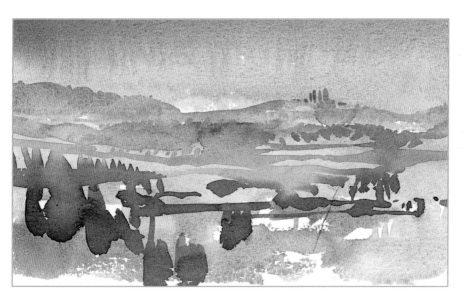

In this landscape, study the artist has used a gradated wash in the sky, fading the colour towards the horizon to give a sense of distance and suggest aerial perspective.

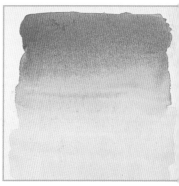

3 Allow the wash to dry naturally, as for the flat wash opposite. It should appear to gradate in tone. The wash should appear even: the paint should not dry in streaks.

Laying a directional wash

Once you have become familiar with the basic wash techniques, you can adapt these to achieve specific effects in your artworks. For example, a directional wash can be used to introduce a sense of movement.

The painting here depicts a fine, fair-weather day with a degree of movement in the sky. Such a sky is best painted by first applying an underwash of the key sky colour – on a fine day this will usually be a combination of ultramarine and cerulean blue. The paint mix should be applied as a gradated wash to wet paper and allowed to dry (see page 23). Once the whole sky is dry, the clouds can be painted on top of the sky colours using a watery wash of the cloud colour (Payne's grey and alizarin crimson in this picture), pulled in a diagonal direction from bottom left to top right.

If you don't reload your brush with paint too frequently, you will be able to create some 'broken' brush marks that will allow the sky underwash to show through.

Finally, you can lighten certain areas by blotting with a piece of kitchen paper.

Colour can be used to suggest movement. Although too many colours in any one sky may be confusing, a number of tones of different colours can help to suggest high, thin clouds. A sense of movement can also be created in skies by employing a diagonal, sweeping brushstroke, easing off the pressure towards the end of the motion to gently release any paint left on the brush.

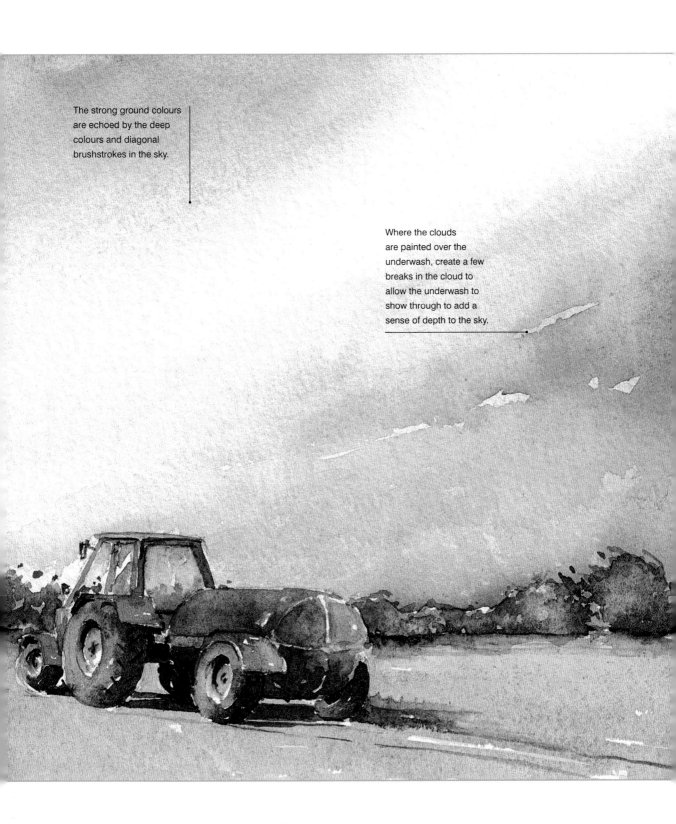

The strong ground colours are echoed by the deep colours and diagonal brushstrokes in the sky.

Where the clouds are painted over the underwash, create a few breaks in the cloud to allow the underwash to show through to add a sense of depth to the sky.

Laying a variegated wash

A two-colour or variegated wash involving more than one colour is less predictable or controllable than flat or gradated washes. By applying two washes together and allowing the colours to move and blend freely, you will achieve some subtle and effective results.

A variegated wash has many uses, from the range of colours in a sunset to the subtle skin tones of a portrait study.

Start by damping the paper lightly with clean water. Then, mix two palettes of the colours that you wish to blend and apply a wash of the first colour. While still wet and with clean colour, apply the second wash adjacent to the first. Take care not to move the brush about, but tilt the paper slightly to encourage the colours to merge naturally.

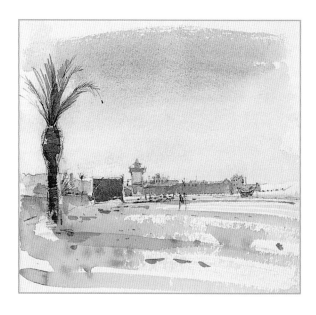

This sketchbook study of a Moroccan scene shows the subtle changes in the sky at dusk. The artist used a variegated wash to suggest the warm glow of the setting sun along the horizon, with a darker blue at the top.

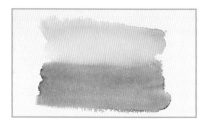

1 Lightly dampen the paper with a clean, moist sponge. Mix a thin red wash from alizarin crimson and load the brush. Lay a wash of red on the top half of the paper.

2 Turn the paper upside down and lay a wash of cadmium yellow, stopping at the edge of the red wash. The two washes will start to blend together. You can turn the paper again to encourage the mix if necessary.

3 Leave the washes to dry. The finished wash will be lighter and the soft blend between the two colours will be subtle.

Leaving white areas in a wash

Watercolour is a medium that requires a certain amount of dexterity and spontaneity with the brush. It demands practice and experimentation in order to control the paint and make use of the white of the paper. Leaving white areas in a wash will create a lively immediacy that can only be achieved with a larger-sized brush, and relies on having plenty of pre-mixed wash. Knowing when to stop is the key. Try to use the minimum number of strokes, as 'dabbing' will create fussy areas.

Working quickly can occasionally cause problems. For example, if you leave an unintentional white area in a flat blue-sky wash, it will be difficult to remove or to paint over later. Plan your painting as much as possible before you start, using an underdrawing to outline the main elements of the composition or by leaving a dry area when damping the paper before laying a wash.

For detailed areas of white, such as windowpanes or a textile pattern, it is best to use a resist technique (see page 68).

The artist carefully planned the progression of this painting to maintain the white of the paper to define the snow on the distant hills, the whitewashed farmhouse and the fence posts leading the eye into the picture.

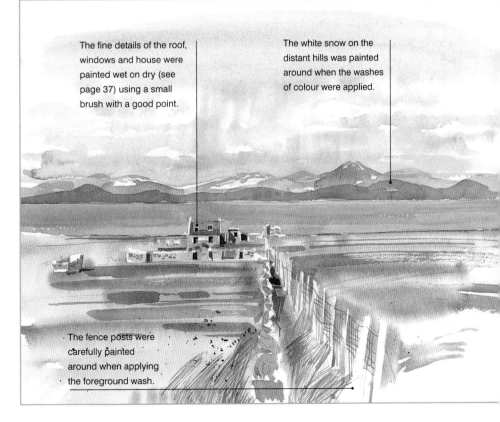

The fine details of the roof, windows and house were painted wet on dry (see page 37) using a small brush with a good point.

The white snow on the distant hills was painted around when the washes of colour were applied.

The fence posts were carefully painted around when applying the foreground wash.

Layering washes

In principle, the fewer washes, or glazes, used in a watercolour painting the better. The primary wash should be simple, establishing a tonal base, and each successive layer or brushstroke should be darker, working from light to dark. This way of building up colour is the main method of working in watercolour. (Of course, there are other techniques that can also be used, such as wet on wet and drybrush; see pages 32 and 82.)

Three or four washes, or layers, of colour are often all that is needed to complete a painting, as watercolour is most effective in its simplicity. Too many colours laid over each other will create a muddied effect. To keep your painting under control, start with medium or large brushes, adding detail with smaller brushes if necessary.

Layering washes of the same colour can be used to suggest recession or changes in tone. Layers of different colours (or glazes, see page 30), can be used to create tertiary colours.

Materials

Arches rough paper 300gsm (140lb), sponge, no. 2 and no. 8 squirrel brushes, watercolour paints

A shoreline with distant cliffs offers a range of subtle tones for the watercolour painter to tackle. In this example, the artist used simple glazes of colour to build soft gradations for the beach in the foreground, echoing the tonal layers for the background cliffs.

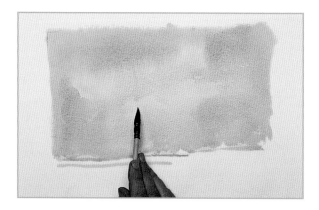

1 Lightly dampen the paper with a clean, moist sponge, applying more water at the top and less along the horizon. Leave a dry area in the middle of the sky to represent clouds. Mix a light wash from French ultramarine and ultramarine violet and apply it with a no. 8 brush. Add a touch of raw sienna to the clouds.

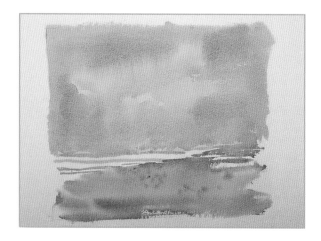

2 Mix a light wash of raw sienna and apply to the foreground with the no. 8 brush. Mix a wash from sepia tone and sap green and work wet on wet (see page 32) over the raw sienna. Spatter the green mixture over the foreground to break up the flat tone. Then, using the no. 2 brush, apply a wash of ultramarine violet mixed with a little wash from Step 1, over the distant cliffs and along the horizon.

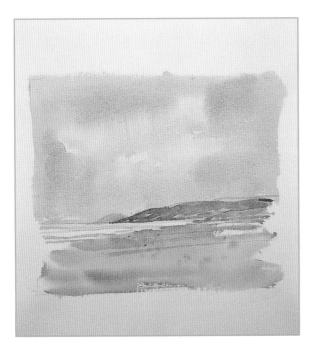

3 Mix a darker wash from ultramarine violet, viridian and burnt umber and overlay this on the distant cliffs. Leave a small gap at the top to give the impression of recession. As the washes dry, the different layers will be more clearly defined. Apply pure viridian along the shore. Add long streaks of colour with a dry brush on the foreground.

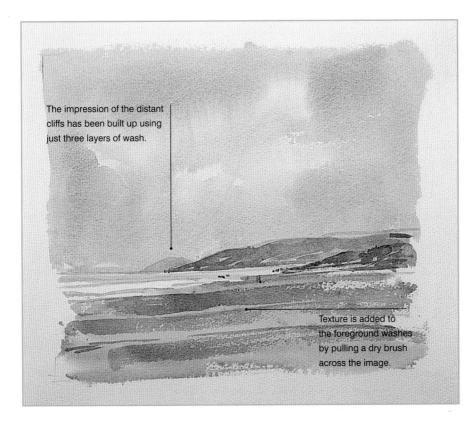

The impression of the distant cliffs has been built up using just three layers of wash.

Texture is added to the foreground washes by pulling a dry brush across the image.

4 Use a warmer mix on the foreground from ultramarine violet, burnt umber and a little viridian. Use a dry brush to add broken texture to the strokes of colour along the shore. Once the painting is dry, the different layers are clearly visible.

Glazes

A glaze is a thin, transparent layer of paint applied over a previously painted area. Glazes are used on top of one another to build up depth and modify colours. Once the first wash is dry, a second wash is laid and the colours are built up.

Watercolours are very transparent, with a few exceptions; traditionally in watercolour painting, light colours are the first washes, with two or three glazes added on top. You can either build up darker tones of the same colour using glazes, or overlay different colours, thus creating tertiary colours, with these superimpositions.

Capturing skin tones in watercolour

The translucent nature of watercolour paint makes it an ideal medium for capturing the subtle changes of hue that occur in skin tones, as you can build up layers of thin paint until you achieve the correct tone. The traditional watercolour technique of working from light to dark should prevent you from painting colours that later prove to be too dark, or even painting them in the wrong place.

Materials

Not watercolour paper, 4B pencil, medium round brush, gum arabic, paper towel, watercolour paints

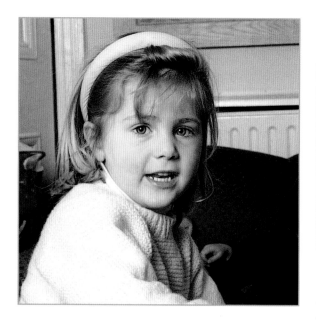

Children find it difficult to sit still for long, so, unless you are making a sketch, you may find it easier to work using a photograph as reference.

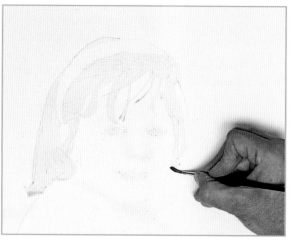

1 Draw in the shape of the girl's head, using a 4B pencil. Try to keep your marks as light as possible, otherwise they may show through the later watercolour washes. Mix yellow ochre and a little cadmium lemon to make a suitable light tone for the hair. Use the brush to paint in this wash.

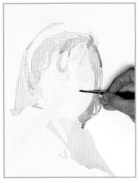 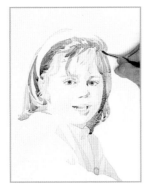 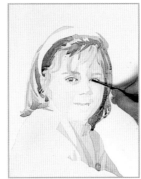 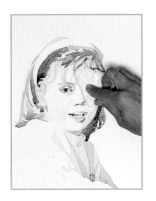

2 Mix Naples yellow with a little cadmium red to make light washes for the face. Darken the hair using burnt umber and yellow ochre, and paint the sweater with a mixture of cadmium lemon and yellow ochre.

3 Add a little gum arabic to the increasingly darker mixes that develop the colours and tones. Paint in the detail around the eyes and mix Payne's grey and ultramarine blue together for the iris.

4 Once the iris is dry, paint the dark part of the eye with a mixture of raw umber and a little gum arabic. When this is dry, touch a little water into the dark of the eye to loosen the paint.

5 Use a paper towel to blot off the dissolved paint, leaving a highlight in the eye. Carefully lighten each iris in the same way.

6 Work darker glazes into the shadows and the hair. If you think any areas are too dark, lighten them using the blotting-off technique described in step 5.

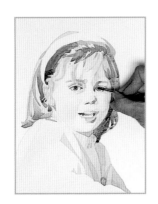

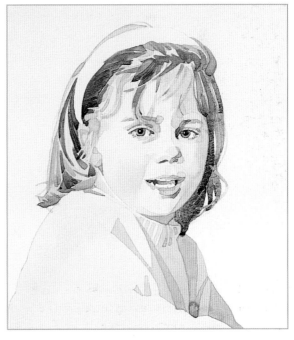

The finished painting

The subtle changes of hue in skin are ideally suited to the delicacy of watercolour glazes. The combination of crisp, wet-on-dry and softer, wet-on-wet washes works very well. Adding gum arabic increases the intensity and translucency of the colours and allows them to be manipulated by re-wetting.

Working wet into wet

Working 'wet into wet' means applying watercolour paint to damp paper and allowing the paint to spread. It is a slightly unpredictable method: the paint will spread and blur to varying degrees depending on how wet the paper is.

The technique allows you to apply one colour over another so that the colours blend together. You can also apply another layer of the same colour, creating areas of darker tone without any hard edges. Use a high proportion of paint to water in your mixes, otherwise they will look watery and weak when dry.

Different wet-into-wet effects

The extent to which the paint will run and blend will depend on the dampness of the paper. It is difficult to control the paint once it has been applied to wet paper, and soft, accidental effects can occur. For more control when using different colours, allow one colour to dry slightly before applying the next. The drier the paper and the more pigmented the paint mix, the more control you will have and the more definite the marks you create will be.

When the paper is damp, the paint blurs at the edges but remains controlled.

Applied to very wet paper, the paint bleeds and feathers.

With only slightly damp paper, the effect is confined and controlled.

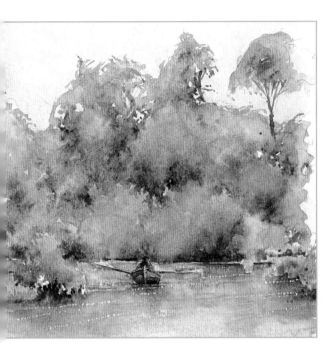

Wet-into-wet reflections using all colours used on the boat were painted here, and were allowed to mix on the paper rather than being pre-mixed in the palette.

Subjects to paint wet into wet

The wet-into-wet technique is ideal for atmospheric effects such as skies (see project overleaf), sunsets, reflections, rain and mist, but can be used for any subject where a soft, transitional effect is required, as in the examples here.

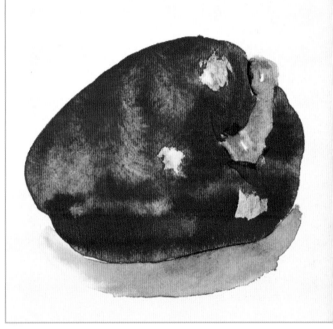

Here the artist has worked wet into wet to capture the shiny and undulating surface of a red bell pepper, using cadmium red and alizarin crimson. The colours have merged and blended slightly on the paper, creating a three-dimensional effect that suggests how the light hits some facets of the paper while leaving others in shade. The pepper appears glossy and the white highlight areas give an illusion of depth. A shadow of Payne's grey around the bottom edge of the pepper enhances the three-dimensional effect.

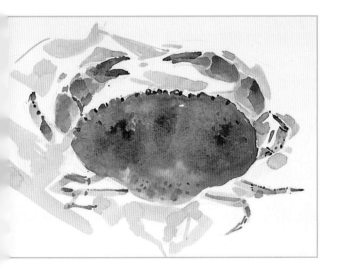

Here the artist has captured the subtle variations in colour across a crab's shell with the wet-on-wet technique.

Skyscape painted wet into wet

This moody scene of a stormy sky at sunset is the perfect opportunity to try working wet into wet: the limited colour palette and simple shapes of the foreground trees allow you to concentrate on getting a feel for how far the paint spreads on damp paper. Knowing how wet the paper should be is something that only comes with practice, however, so don't worry if your first attempts do not turn out as you expected.

Materials

Heavyweight watercolour paper, 2B pencil (optional), medium round brush, paper towel, watercolour paints

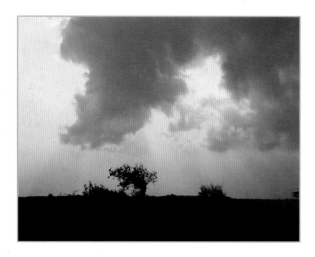

This moody sunset, with brooding storm clouds, makes a dramatic subject for a watercolour sketch. Although the landscape beneath is so dark that virtually no detail is discernible, it sets the scene in context and helps to anchor the painting.

1 If you wish, sketch the foreground trees and main cloud shapes using a 2B pencil. Keep your pencil marks very light, however, otherwise they may show through in the finished painting. Wet the whole of the paper with clean water. Touch very dilute Naples yellow into the sky area around the heaviest cloud mass, changing to cadmium orange towards the base of the sky.

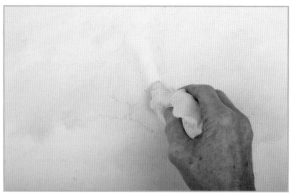

2 Dab or stroke a scrunched-up piece of paper towel onto the paper to wipe off paint in the very lightest parts of the sky and create the effect of sunlight coming through the clouds.

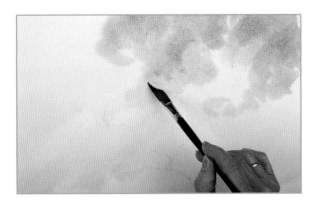

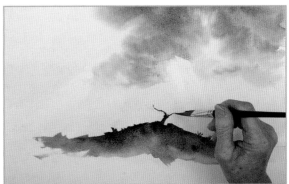

3 Mix a dark purple-blue from dioxazine violet and Winsor blue. While the paper is still damp, brush in the basic shape of the dark cloud.

4 Add burnt sienna to the violet/blue mix from the previous step and touch in the darker parts of the cloud. Use the same mix to brush in the silhouetted foreground; to make the scene more interesting, the artist decided to change the flat horizon line in her reference photo to a small hill.

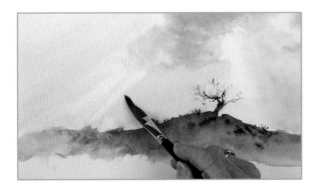

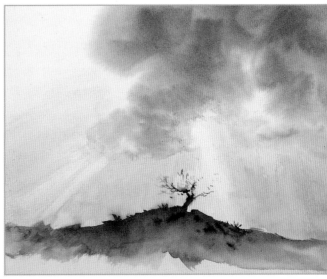

5 Drop tiny patches of neat raw sienna into the foreground to create some tonal variation and a sense of depth. Now that you've put in all the very dark tones, the lightest areas may appear too light; if necessary, dampen the sky area again with clean water and intensify the yellow and orange tones.

The finished painting

This loosely painted skyscape is full of atmosphere. Although the silhouetted foreground takes up only a small part of the final image, it balances the composition and provides a context for the skyscape above. The billowing, soft-edged cloud mass dominates the painting and has a lovely sense of energy.

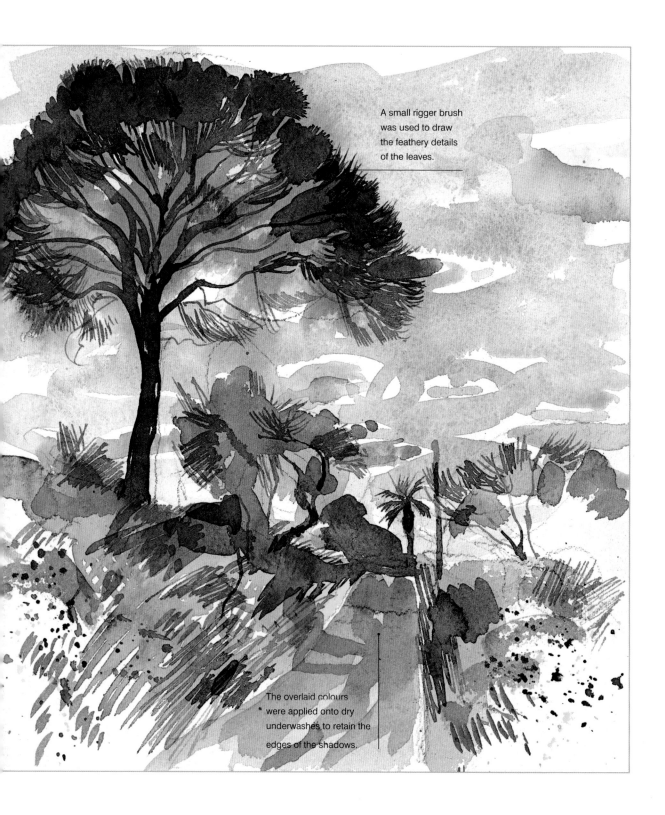

A small rigger brush was used to draw the feathery details of the leaves.

The overlaid colours were applied onto dry underwashes to retain the edges of the shadows.

Working wet into dry

Much of the charm and enjoyment of using watercolour lies in its unpredictability – an effect that can be exploited when working wet into wet. Sometimes, however, you will want to feature the delicate colours and translucency of watercolours while also working with a degree of precision, which calls for working wet into dry.

When working wet into dry, the paint can be controlled by working in layered washes, allowing each one to dry before the next one is applied. Paintings made using this technique are crisp and have a sharp focus, as the paint does not spread beyond the area to which you apply it. To avoid the results looking too hard and clinical, mix tones and colours thoughtfully, separating the work into carefully considered light, medium and dark tones; soften any edges that look too hard by re-wetting and allowing the paint to subtly blend one colour into the next. Studies of buildings or still lifes are suited to the wet-on-dry technique, as are paintings requiring tonal recession, such as mountains in distant landscapes, or the waves in a calm sea.

This magnificent cedar lent itself to a rigger brush (see page 10). The artist worked wet into dry, using light brushstrokes, flicking the brush to follow the feathery shape of the foliage. The shadow beneath the tree helps to anchor it to the picture plane.

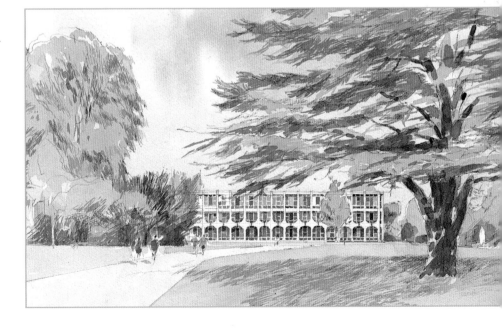

In this landscape painting, the artist painted wet on dry to describe the details of the tree branches and leaf fronds. A rigger brush was used for the leaves, using a relatively dry brush and building colour on the dry wash beneath.

Lifting out

Occasionally you may need to remove paint to create a particular sky or water effect. One method is to remove the colour from a wash while the paint is still wet. A sponge, tissue, cotton buds or a brush are all suitable tools for lifting out. Dab or lightly rub the paint until you have removed the colour.

Your success may depend on the type of paper you use. A smooth paper, such as Bockingford, will respond well, but a rough paper, such as Arches, tends to absorb the colour pigment more readily, making it hard to remove. Experiment on different papers before embarking on a painting where you wish to use this technique. Also bear in mind that some colours adhere to the paper more than others.

Materials
Bockingford rough paper 300gsm (140lb), sponge, no. 8 squirrel brush, kitchen paper, cotton bud, fine brush, watercolour paints

This technique is ideally suited to creating cloud effects. Using a damp piece of kitchen paper or tissue, you can lift out the sky colour to suggest soft, billowing clouds.

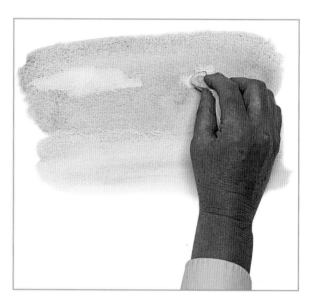

1 Mix a light wash of French ultramarine and lightly dampen the paper with a clean, moist sponge. Apply a gradated wash of blue for the sky area. Dampen a piece of kitchen towel or tissue and apply to the sky, rubbing gently to create a cloud shape.

2 Use a cotton bud for the more linear cloud shapes along the horizon. You can even use a clean, damp brush to 'draw' birds in flight.

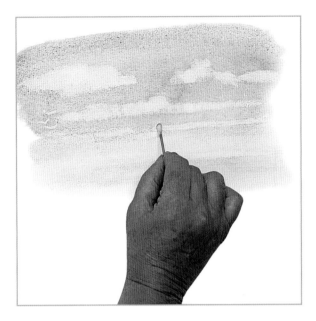

Light clouds can either be created by leaving an area of white paper and painting around it, or by allowing paint to flood the entire sky and then removing some of the wash while it is still damp by sponging or blotting. Timing is important – if you wait too long the paint will have dried, but if you try to remove the paint too soon you will only remove the surface water, leaving the paint to bleed into the damp paper. Wait until a 'sheen' appears on the paper – this will tell you that the surface water has been absorbed and that the fibres of the paper are still damp and that any paint can now be soaked up or blotted accordingly.

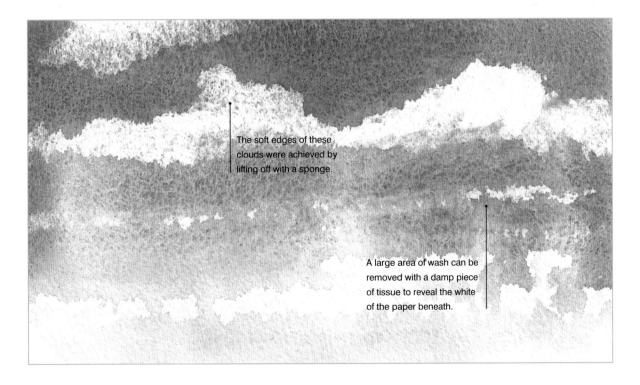

The soft edges of these clouds were achieved by lifting off with a sponge.

A large area of wash can be removed with a damp piece of tissue to reveal the white of the paper beneath.

Backruns

This is a term used to describe areas of a wash that dry with a hard, uneven edge. This mark is sometimes called a 'cauliflower' or 'bloom'. They often occur unintentionally and can be welcome or unwelcome depending on the progress of your painting.

Backruns happen when a second wash is laid over a primary wash that is still damp, leaving an unwanted blotchy patch. Smooth, hot-pressed papers, in particular, encourage blooms more frequently. You can plan backrun areas as part of the painting, using them to represent trees in full leaf, plant forms and skies. However, if an unwanted backrun occurs, the only solution is to wash it off. Use a very damp sponge or large mop brush loaded with water to wash the colours together. The paper will buckle and will need to be restretched before you start a new painting. You can use a sponge or tissue to wipe off mistakes that are wet.

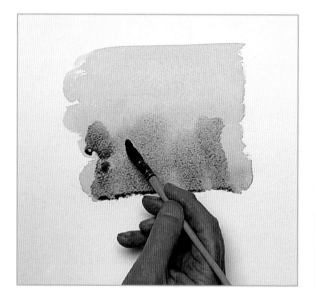

1 Dampen the paper and apply a flat wash of colour. Mix a darker wash and apply this immediately to the damp paper, dotting the colour onto the paper.

2 Leave the paint to spread. As the paint dries, a darker, feathered edge will appear.

In this study from an artist's sketchbook, several accidental backruns have occurred, which add to rather than detracting from the subject.

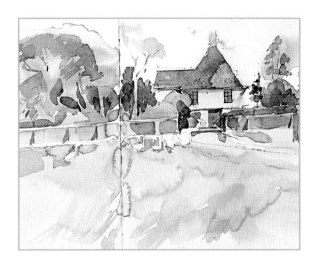

Backruns can be exploited to create a sense of movement in a landscape. In this painting of fields and sky, the artist painted very loosely and let messy things happen – including backruns, unblended markings and rough edges. Some colourful spatters in the foreground suggest a sprinkling of wildflowers.

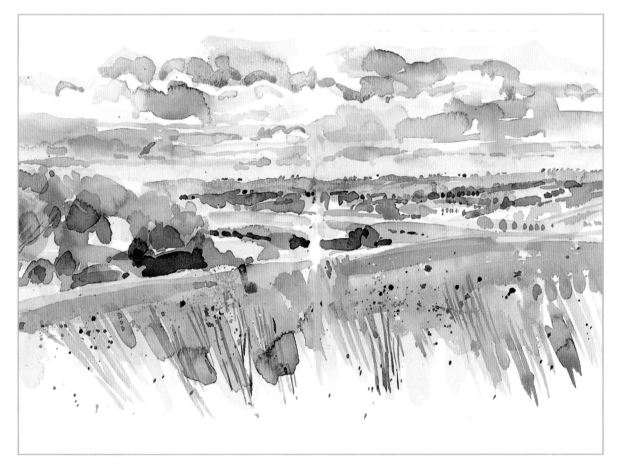

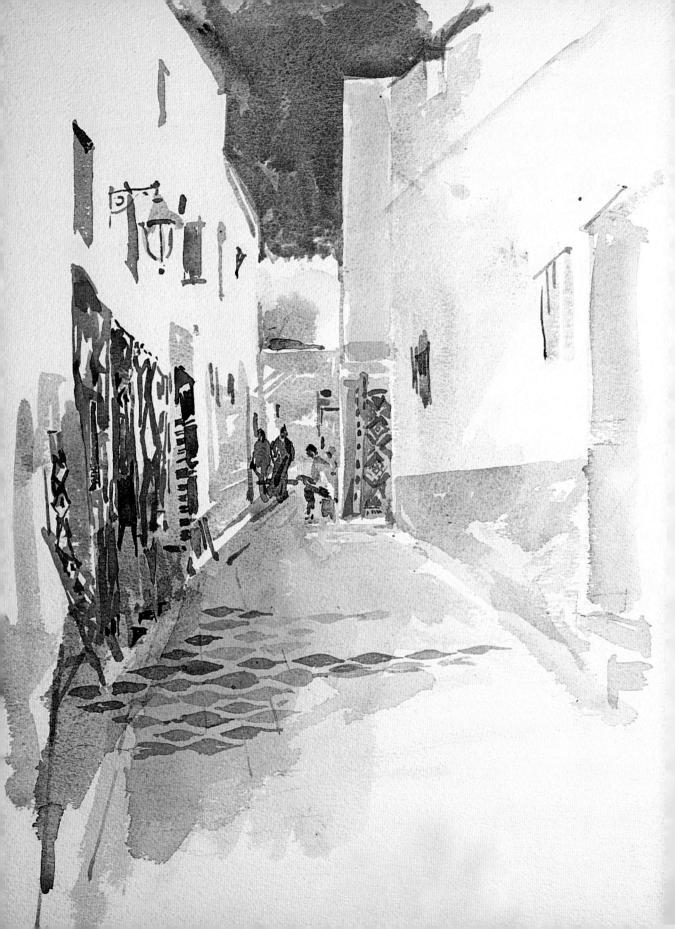

Understanding Colour

Watercolour is renowned for its translucency and the way the paper shines through the paint. Good watercolour paintings can convey a feeling of light and airiness that is unmatched by any other medium. However, that quality of translucency imposes technical restraints. You must always work from light to dark; you can overlay light areas with dark colours, but not the other way round. In this section we introduce some basic theories of colour and lead you through some ideas on how to mix the colours you will need to create successful artworks.

Mixing colours on paper

Learning to mix colours and control the results is one of the main skills in watercolour painting. As discussed in the previous section, you can mix colour on paper by laying wet colour over dry paint. This enables you to exploit the translucency of watercolour paint. When dry, each layer allows the particles from the previous layer to show through. You can mix two colours in this way to produce other hues.

Be aware that watercolour paint always looks lighter when it is dry. Either test your mix on scrap paper and leave it to dry so that you know in advance what the final colour will be, or build up the tones gradually until you achieve the effect you want.

Mixing a secondary green

As landscape is such a popular subject with watercolour painters, you will probably want to become skilled at mixing greens.

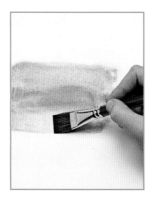

1 Brush cerulean blue onto the paper with a flat brush, using even strokes, then rinse out your brush. Allow the paint to dry completely.

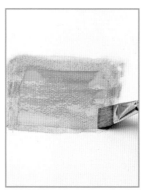

2 Add a second flat wash of cadmium yellow on top of the cerulean blue. Take care not to go over the same area of paper twice with this wash.

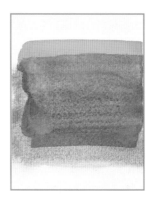

3 As the cadmium yellow begins to dry, it becomes translucent and allows particles of the blue paint to show through. Although both colours are apparent, they mix optically, producing a secondary green tone.

Other mixes

Experiment with watercolour washes to see what colours you can produce on paper.

Blue on crimson

Here, a flat wash of alizarin crimson was painted onto the paper and allowed to dry. Next, a flat wash of cerulean blue was applied, overlapping the crimson. Where the colours meet, a secondary violet colour appears.

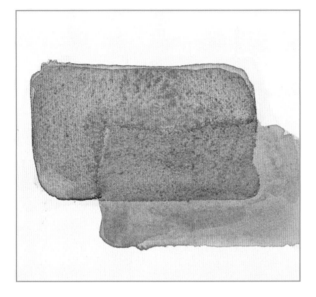

Yellow on green

Here, a flat wash of Hooker's green light was painted onto the paper and allowed to dry. Next, a flat wash of cadmium yellow was applied, overlapping the green. Where the colours meet, a yellow-green tone appears.

Building up a single colour

Layer upon layer of one hue can be built up on the paper to achieve a darker tone. The effect is similar to placing several layers of tissue paper over one another, as the translucent paint allows the underlying layers to show through.

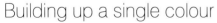

Mixing colours on the palette

You have more control if you pre-mix colours on a palette. A partitioned porcelain palette, like the one shown here, is useful for mixing colours. Place one colour in the first trough, another in the second, and then mix the two in the third to create the colour you want. Always mix more paint than you think you will need and have a jar of clean water at hand so that you can wash out your brushes.

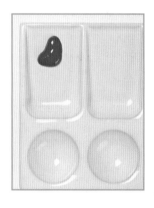

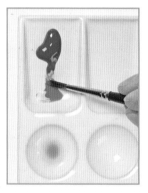

1 Spread a little watercolour paint (here, cerulean blue) from a tube into the first slanted section of the palette. Put some clean water into the round well at the bottom of the partition.

2 Wet your brush in the water and touch it into the paint so that the paint dissolves slightly and begins to run down to the bottom of the slanted section. Pull down more paint with the brush.

3 When you have achieved the intensity of colour that you want, wash out your brush.

4 Repeat steps 1–3 in the second slanted section, using another colour – here, cadmium yellow. Again, wash out your brush.

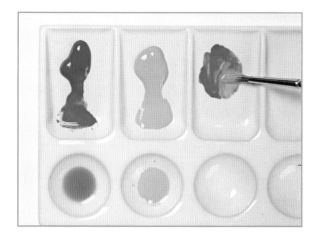 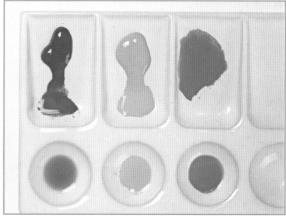

5 Dip the brush in the blue pool and then move to the third slanted section. Place the paint there, rinse your brush again, then add yellow. Mix the colours together.

6 As the two colours mix, green will emerge. The colour will vary as you change the relative amounts of blue to yellow or of water to paint.

Careful mixing of your colours in the palette will help you achieve a harmonious and subtle range of colours, as in this serene lakeside scene.

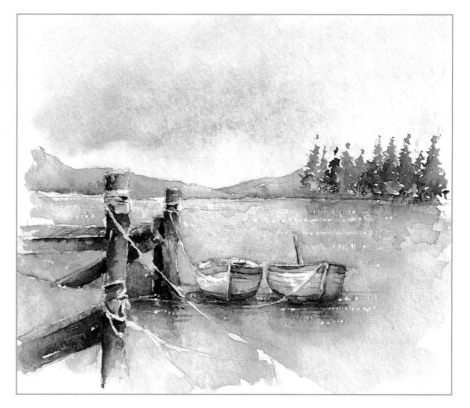

Basic colour theory

At first glance, colour theory can seem complex and daunting. However, once you understand the basic ideas, you will begin to see why some colour mixes work better than others.

The primary colours – red, yellow and blue – are those that cannot be created by mixing other colours. The secondary colours – orange, green and purple – appear when each primary is mixed with its neighbour.

Mixing a primary colour with one of the secondary colours that lies next to it on the colour wheel creates what is known as a tertiary colour.

Complementary colours are those that are opposite each other on the colour wheel: mixed together they tend to neutralize each other (a useful way of creating neutral greys and browns), but placed next to each other they appear to increase in intensity.

The colour wheel

The colour wheel is a classic way of illustrating the relationships between different colours. To help you to understand how colours can be created, it is worth painting your own colour wheel, starting with the primary colours from ready-made pigments and then mixing the secondary and tertiary colours. You will soon discover that there are many different mixes that can be created with different dilutions of water to paint and different proportions of pigment and wash.

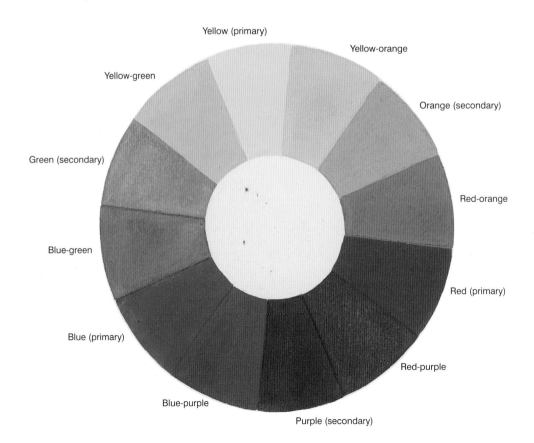

Yellow (primary)
Yellow-orange
Yellow-green
Orange (secondary)
Green (secondary)
Red-orange
Blue-green
Red (primary)
Blue (primary)
Red-purple
Blue-purple
Purple (secondary)

Colour temperature

Another key concept in colour theory is understanding colour temperature. Any red, yellow or blue has a warm or a cool bias. Cadmium red, for example, is a warm red; when mixed with cadmium yellow, it creates a warm orange. However, alizarin crimson (a bluish and therefore cool red) mixed with cadmium yellow produces a cool orange. Winsor blue has a cool bias, whereas French ultramarine has a warm bias.

Warm colours appear to come forward in a painting, while cool ones recede – so one way to make something appear further away is to paint it in a cooler hue.

In order to be able to mix a full range of colours, you need to include a warm and a cool version of each of the three primary colours in your set of paints. By mixing colours with a similar temperature bias you can create muted mixes that maintain harmony across the painting.

Warm and cool greens

The colour mixes below show how different greens can be mixed from warm and cool blues and yellows.

Cerulean blue + chrome lemon yellow = cool green

Ultramarine + chrome lemon yellow = warm green

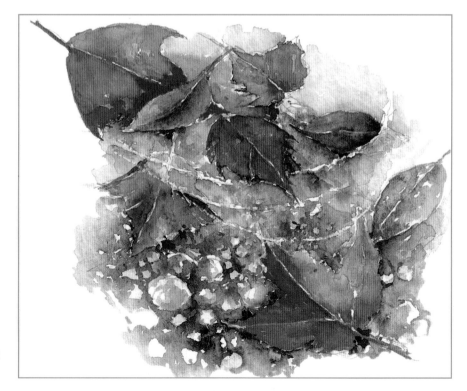

Autumn scenes are the perfect opportunity to explore creating a unified warm-toned palette.

Working with a limited palette

It is possible to paint fine watercolours using mixes created from just the three primary colours: red, yellow and blue. These can be mixed to make secondary and tertiary hues to give you a surprisingly varied palette.

A small, limited palette of five colours (blue, yellow, red, brown and green) encourages experimentation and mixing, and will help you to understand how colours work and how to achieve your own customized mix. Practise mixing colours in different dilutions and proportions – you will be amazed at the range of tones and hues that you can achieve with just a small selection of colours.

A basic palette could include:
Blues: French ultramarine, cobalt (extras: cerulean and ultramarine violet)
Yellows: cadmium lemon, yellow ochre or raw sienna (extras: Naples yellow, (opaque) gamboge or aureolin)
Reds: cadmium red, light red, alizarin crimson (extras: Venetian red)
Brown: burnt umber, sepia
Green: viridian, sap green

Materials
Rough paper 300gsm (140lb), 4B pencil, medium squirrel brush, no. 4 sable, watercolour paints

This landscape was painted using the primary colours: gamboge (yellow), light red and cobalt blue. Always test your mixes first on a piece of scrap paper and remember that watercolour paint is lighter when dry.

1 Lightly sketch in the composition. Wet the paper and mix a light blue wash of cobalt blue. Use a medium squirrel brush to apply the wash to the sky, leaving some areas white to represent clouds. Use the wash to add tone to the road in the foreground. Mix a neutral tone from cobalt and light red and apply to the sky to add depth.

2 Mix a very light green from gamboge and cobalt blue, in approximate proportions of 3:1. Apply this to the trees and hillside. Make a thin, watery wash of light red and apply this over the blue on the road and roofs to add a warm tone.

3 Wet the tree areas, then mix a green wash from cobalt blue and gamboge and apply with a no. 4 sable brush. Introduce some detail to the roof using a pure wash of light red. Mix gamboge and light red to make a pale orange wash for the warm terracotta buildings.

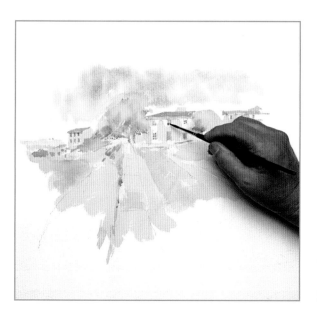

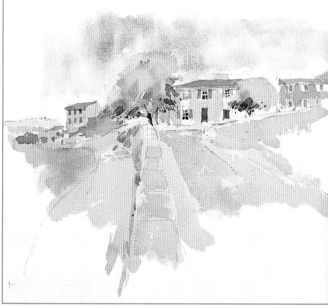

4 Mix a dark purple from cobalt with a touch of light red and add the window details and areas of shadow on the buildings.

5 The finished painting shows how a subtle depth of colour can be achieved with varied mixes of just three colours.

Working with tone

Understanding tone is a key component in skilful colour mixing. The term 'tone' simply means the relative lightness or darkness of a colour. Being able to judge tones correctly is essential, as it enables you to create a convincing impression of light and shade, a key factor in helping to make your subjects look three-dimensional.

The tone of an object depends on the degree and quality of light falling on it. If one side of a building is in sunlight and the adjacent side is in deep shadow, the shaded side will appear considerably darker – even though both sides are made from the same materials and are the same colour.

It can be difficult to work out which tones are light and which are dark: colours that are close in intensity and hue can appear to be the same tone. You may find that it helps to imagine your subject as a black-and-white photograph.

Light that falls consistently all over a subject will make it appear flatter than it is in reality; this is due to a reduced range of tonal values. Stronger directional light, with a wide tonal range and a greater degree of contrast, has the effect of accentuating shape, form, contour and texture.

Tone with relation to colour

Some of the terms used in relation to tone are hue, shade and tint.

Hue is another word used by artists to describe pure colour.

A shade is a hue that has been darkened.

A tint is a hue that has been lightened.

The watercolour artist creates shades and tints where mixes are diluted or darkened as the painting develops. The balance of these colours, and their progression from light to dark, will help to build a realistic impression of light and shade, and depth and form within a painting.

To understand the range of shades and tints that can be created from one colour, try to make your own tonal scale, like the one shown below. Start with a pure tube colour, then darken this either with the addition of black or by adding a complementary colour. At the other end of the scale, add white to lighten the colour to create tints or dilute the colour with water to create a paler wash, increasing the amount of water each time. Shades and tints can also be created by layering washes, or applying glazes, of the same colour.

Create your own tonal scale by darkening and lightening pure pigment.

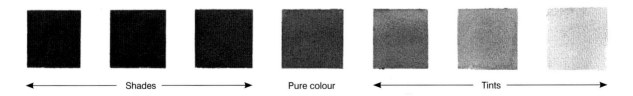

◄——— Shades ———► Pure colour ◄——— Tints ———►

This simple painting uses a range of tones to convey light and shade, as well as form.

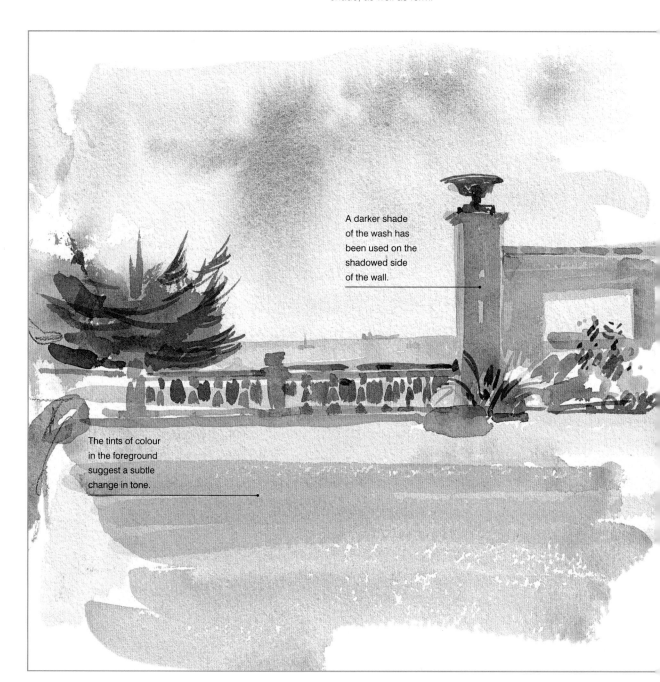

A darker shade of the wash has been used on the shadowed side of the wall.

The tints of colour in the foreground suggest a subtle change in tone.

Tonal painting in monochrome

Working in monochrome is a good way to increase your understanding of tone. In this exercise, all the wooden objects are exactly the same colour, but in order to make them look three-dimensional, you need to assess the tones and work out how dark and how light to make them.

Start by applying the very lightest tones and then build up layers of paint for the mid- and dark-toned areas. Watercolour paint always looks a little darker when wet than it does when dry, so you may find that you need to paint the mid- and dark-toned areas again in order to achieve the right tone.

Materials

HP watercolour paper, 2B pencil, plastic eraser, medium round brush, watercolour paints

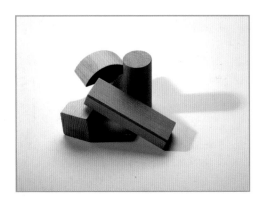

Arrange a selection of wooden shapes on a white surface with a light (a table lamp will do) positioned to one side, so that the objects cast strong shadows.

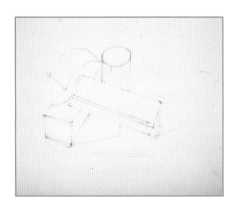

1 Using a 2B pencil, lightly sketch the outline of the shapes.

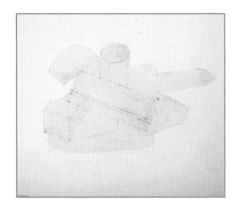

2 When you are happy with your sketch, knock back the outlines with a plastic eraser so that you can only just see where the lines are. Mix five tones of blue-grey from ultramarine blue and raw umber. Apply the very lightest tone over all the objects, including the shadows, and leave to dry.

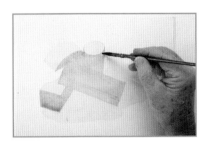

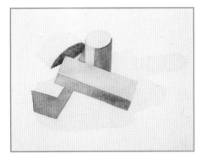

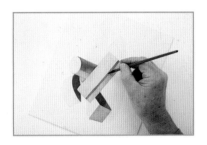

3 The lightest tones are on the tops of the cylinder, semi-circle and curved piece on the left-hand side of the image, so these areas will receive one layer of paint only. Apply the second-lightest tone over the remaining areas (but not the shadows), then leave the piece to dry.

4 Apply the third tone to the shaded areas of all four objects. Note that there is a gradual transition in tone on the cylinder: only the right-hand side, which is furthest from the light source, needs this third tone. Leave to dry.

5 The right-hand sides of the semi-circle and the curved piece of wood, and the dark strip along the edge of the rectangular block need to be darkened still further: apply the fourth tone here and leave to dry.

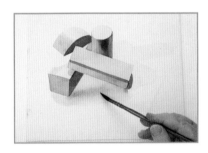

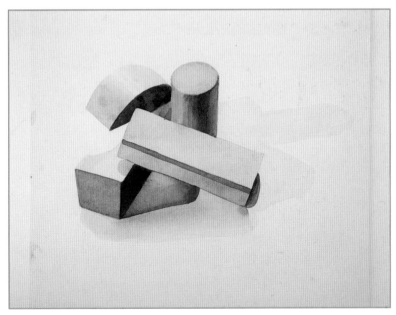

6 The tone on the two curved surfaces (the top of the semi-circle and the sides of the cylinder) is gradated, because they curve gradually away from the light. To achieve this gradation, add water to your mix to lighten it. Put in the dark shadow cast by the rectangular block on the curved block and table top.

The finished painting
Careful observation and rendering of the different tones has resulted in a sketch that looks convincingly three-dimensional.

Using coloured paper

Another way of introducing colour into your artworks is to work with coloured paper. Watercolour achieves its transparent quality partly from the medium itself and partly from the white paper that adds to its luminosity. However, it is possible to use alternative papers that are coloured or toned. You may need to use opaque white gouache (see page 18) to achieve light or white areas of the painting.

There are many different papers available and many different colours, ranging from greys and greens to blues and browns, but you will need to use light tints if selecting a coloured paper. Your choice may be governed by the subject matter and the feel of the painting – a cool blue for a sky study, for example, or a pale grey for a cold, rainy landscape. Warm creams and browns are suitable for figure studies.

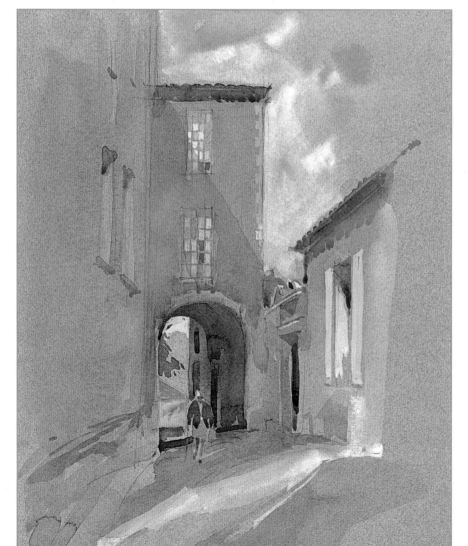

Left: The artist chose a tinted handmade paper, known as Turner's blue, for this painting. The tone unifies the shaded buildings.

Right: Ordinary brown wrapping or kraft paper stretches well to produce a flat, receptive working surface. The artist drew this figure in sanguine pencil, adding loose watercolour and gouache washes on top.

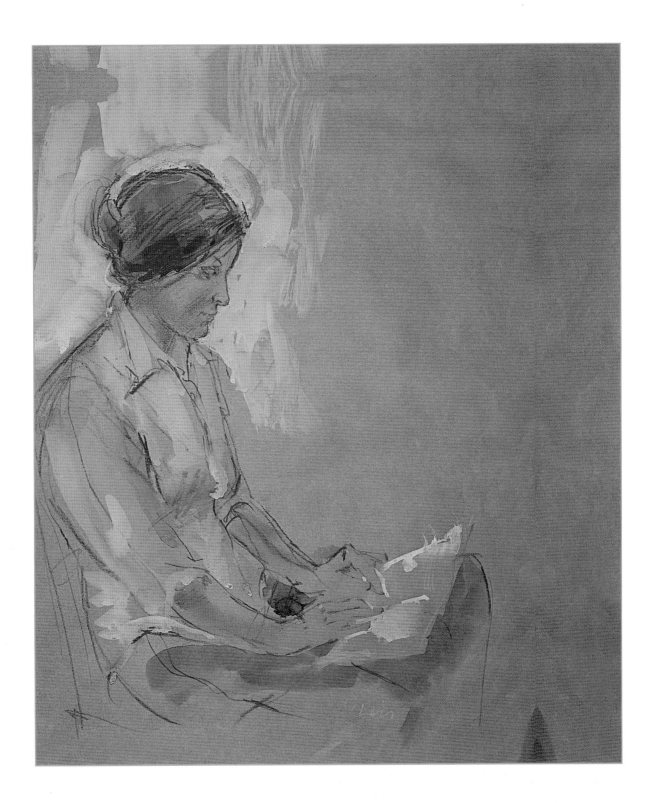

Don't be concerned about mixing warm and cold colours together in a composition (such as warm greens and cool yellows) – often they work particularly well.

Using water as the medium, a wider variety of tones can be mixed on the paper.

Spring palette

Watercolour painting is a medium uniquely well suited for capturing landscapes and the shifting seasons, and in this section we give you some guidance on how to mix colour palettes to suit specific times of year. This will give you good practice in mixing up colours and also some insight into balancing warm and cool colours.

Spring colours tend to come from the cooler end of the colour spectrum – predominantly blues and lemon yellows.

The season's freshness can be recreated by informed choices about colour mixes. The cooler blues are cobalt blue and Winsor blue; Hooker's green has a strong blue element. Cadmium yellow can be used in spring forest scenes, but mixing in a little lemon yellow freshens the colour. The cool violets of bluebells, for example, can be mixed with Winsor or cobalt blue and a touch of permanent mauve. Although Winsor blue can be good in skies and greens, it can be rather overpowering on the ground.

The freshness of this spring glade was achieved by using a combination of lemon yellow and sap green. The white highlights – created by leaving the paper unpainted – also help to create the atmosphere of the scene.

Few of the range of spring colours are used 'neat'. They need extensive mixing as not many of them are 'natural' colours. You can mix these paints in the palette or on the paper itself, using the surface water to carry the paint and mix it for you.

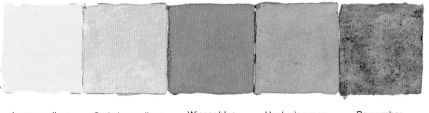

| Lemon yellow | Cadmium yellow | Winsor blue | Hooker's green | Raw umber |

Summer palette

The sun-filled days of summer are best recorded using a selection of yellows and greens, reserving a little warm violet for the shadows. Sap green is a good starting point, adding the warmer cadmium yellow to develop the highlights.

The more sunlight, the stronger the shadows, and these can be painted using a mixture of ultramarine with a touch of alizarin crimson or burnt umber. Both these colours have warm qualities and are ideal for turning a neutral colour or tone into summer shadows. The sharp, cold light of spring has been replaced by softer summer light, usually resulting in softer-edged shadows. To achieve this, allow the shadows to bleed into damp paper, or blot the edges.

Cadmium yellow was used as the base colour for this summer woodland study. The underlying warmth was achieved by adding raw sienna carefully, making sure that it did not overwhelm the lighter shade of yellow.

The summer palette is, predictably, made up of colours from the warmer end of the colour scale: warm greens, blues and violets are commonly used. A hint of cadmium yellow to warm up green mixes is useful.

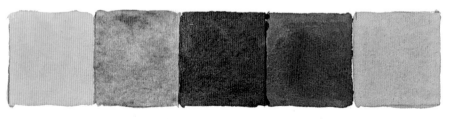

| Cadmium yellow | Raw sienna | Burnt umber | Ultramarine | Sap green |

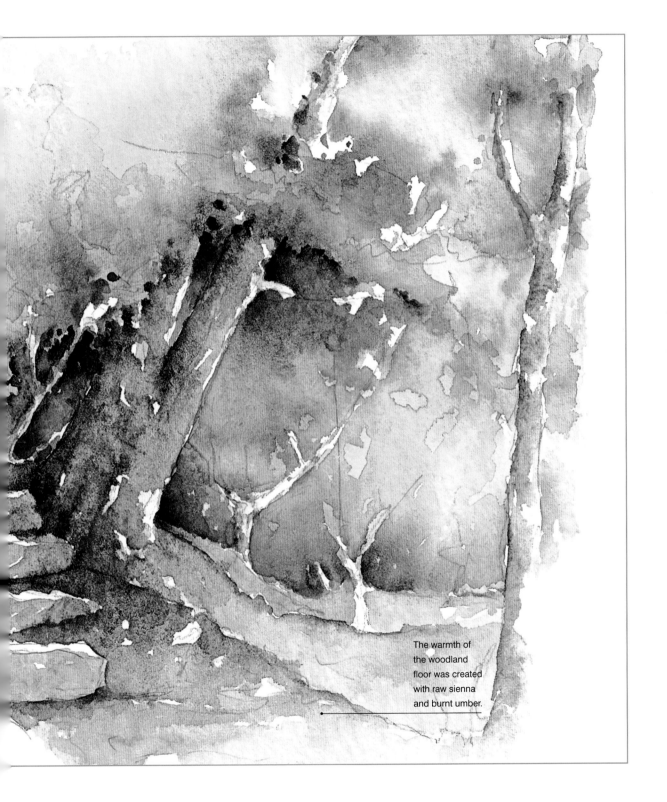

The warmth of the woodland floor was created with raw sienna and burnt umber.

Autumn palette

This is the season of oranges, reds, golds and browns, largely created from the natural earth colours, with the occasional addition of the cadmium family.

Raw sienna is a good catalyst for colour mixes: this warm yellow colour mixes well with siennas and umbers as well as cadmium yellow and cadmium red to aid the 'golden' feel. Burnt sienna, a reddish-brown colour, is a good base for the addition of a few splashes of colour. In small quantities, pure cadmium red can look visually stunning when mixed with raw sienna, and even more so when a few neat flecks are introduced to a scene. Burnt umber and ultramarine work well for shadows.

The rich autumnal colours were created by cadmium red and orange with a touch of burnt sienna, all allowed to blend freely.

The natural earth colours are those colours dug from the mineral deposits that occur in the mountain regions of southern Europe. Given their organic nature, they are ideal colours for an autumnal palette.

| Cadmium yellow | Cadmium orange | Cadmium red | Raw sienna | Burnt sienna |

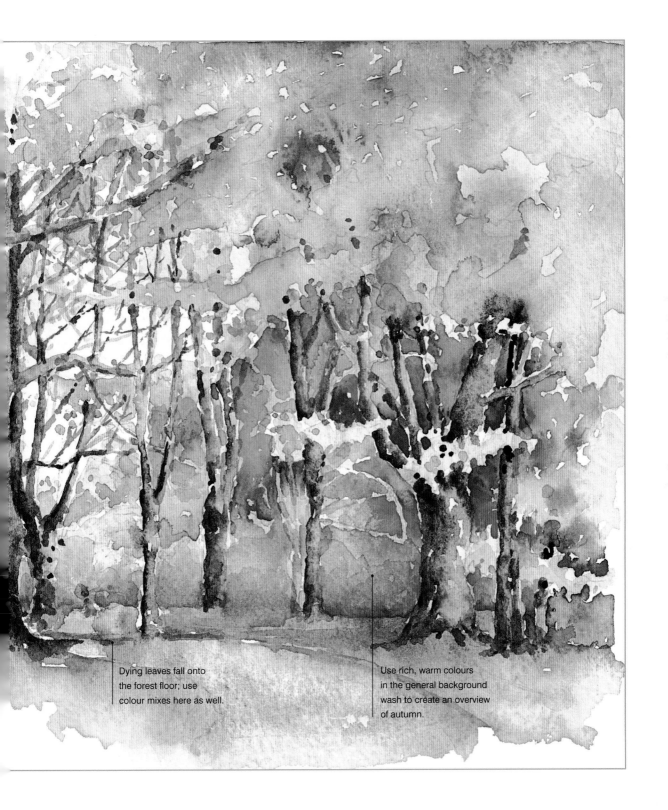

Dying leaves fall onto
the forest floor; use
colour mixes here as well.

Use rich, warm colours
in the general background
wash to create an overview
of autumn.

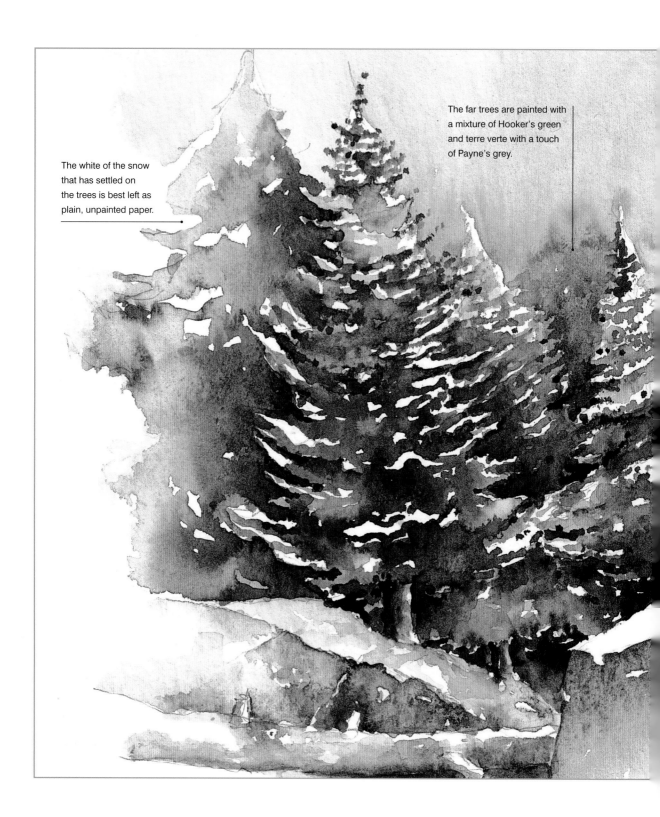

The white of the snow that has settled on the trees is best left as plain, unpainted paper.

The far trees are painted with a mixture of Hooker's green and terre verte with a touch of Payne's grey.

Winter palette

Winter in the woods is usually a time of cold, muted colours, often tinged with grey. Use terre verte (a grey-green) and Hooker's green (a blue-green) as the base for any greenery that still remains. Raw umber is a useful colour to add to your winter palette: this cool grey-olive colour is good for toning trees, branches and general ground cover.

For snow, leave the paper white and paint around it – you can never find a purer or cleaner white than your paper. Snow, however, does hold some degree of tone, depending on the strength of the daylight. A cool blue/violet mixed with alizarin crimson and Winsor blue is a good choice for capturing this effect.

The cold greens were created by blending Winsor blue with a touch of Payne's grey, and using this as a 'mixer' with Hooker's green.

The colours in a winter palette are those that can impart colour without any real richness. Useful paints include terre verte and Payne's grey, which are both very 'thin' colours from the neutral end of the colour range.

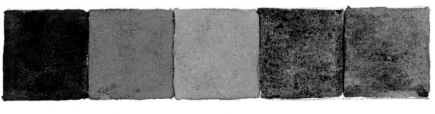

| Payne's grey | Winsor blue | Hooker's green | Terre verte | Raw umber |

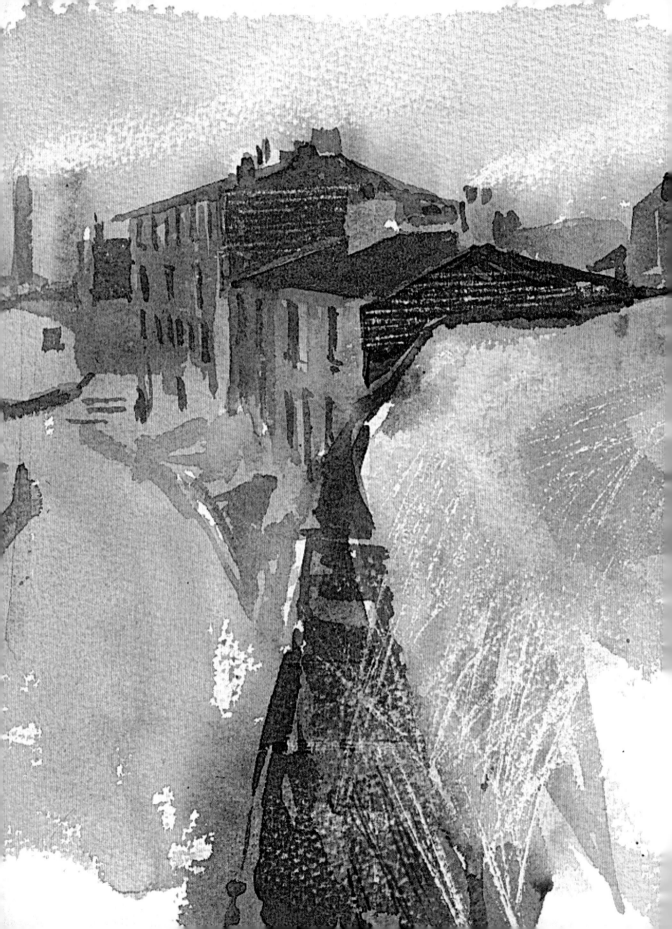

Adding Texture and Effects

Once you are familiar with the core watercolour techniques, you can start adding textures and effects to your artworks. Using resist media is a key way of working highlights or achieving crisp white areas in your paintings, while sgraffito, drybrush and spattering are other interesting ways to add textural effects.

Resist media

Once of the most useful ways of creating effects in watercolour is to use resist media. The main media are masking tape, masking fluid and 'greasy' media such as oil pastels or wax.

Masking methods

Very often in watercolour painting you need to preserve the white of the paper, as traditionally no white paint is used. To do this, mask off the areas that you want to remain white, using masking tape, masking fluid, or even small pieces of scrap paper torn to roughly the right shape.

Masking tape

Buy low-tack masking tape instead of the heavily gummed tape used for office applications; it will not damage the surface of the paper when applied. Masking tape is good for covering large areas. By cutting the tape into sections, you can create sharply defined shapes and areas; by tearing it, you can create softer edges, as the paint will move more freely within the tear lines and a little paint may even seep under the tape.

1 Tear or cut masking tape and place it down firmly on the paper over the areas you want to cover.

2 Apply a wash of colour over the paper, including the tape, and leave it to dry completely.

3 When the paint is dry, peel off the masking tape.

4 The areas that were under the tape remain completely white.

Masking fluid

Masking fluid is available in clear and slightly toned versions; the benefit of the latter is that you can see it even when you have painted over it. Apply it with an old brush in exactly the same way as you brush on paint; you will find that you can create any thickness or shape of line that you want. You can even spatter masking fluid onto the paper (see page 74); this is a good way of creating effects such as sparkling highlights on water. Masking fluid must be allowed to dry completely before you paint over it or the effect will be spoilt. Remember, too, that the fluid can ruin your brushes. Keep old brushes just for use with masking fluid and always wash them out in warm, soapy water immediately after use.

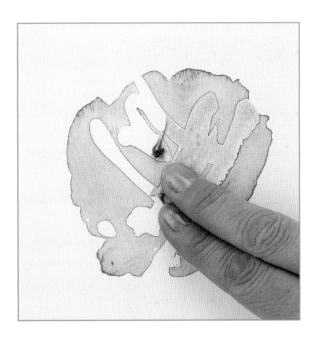

3 Gently rub off the masking fluid with your fingers.

1 Brush masking fluid onto the paper in exactly the same way as you brush on paint and leave it to dry completely.

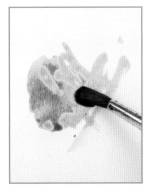

2 Apply a wash of colour over the paper and leave it to dry completely.

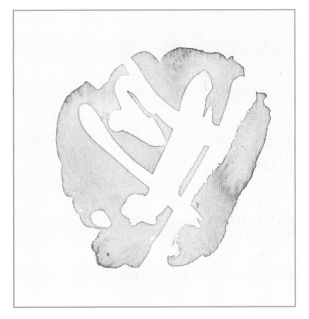

4 The areas that were under the tape remain completely white.

Using masking fluid

This project is a good introduction to using masking fluid to preserve areas of fine detail in a watercolour. Leaf stalks, veins, and other markings are often much lighter in colour than the rest of the leaf. It would be very fiddly to paint right up to the edges of the stalks and veins, but by using masking fluid you can apply a wash of colour over the whole leaf while still preserving the white of the paper.

Materials

Not watercolour paper, 3B pencil, plastic eraser, masking fluid, old brush for masking, fine-nibbed dip pen, medium and fine round brushes, paper towel, watercolour paint

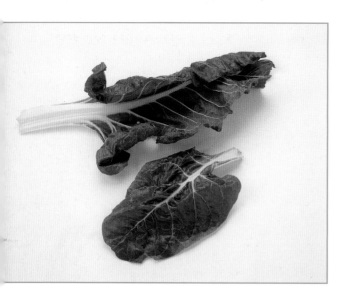

The subject

Arrange your chosen leaves on a plain white background and position a small lamp to one side so that they cast a light shadow on the surface. Although you do not want the shadows to become too dominant, a hint of shadow will help to anchor the leaves on the surface and make them look more three-dimensional.

1 Using a 3B pencil, sketch the leaves, indicating the folds in the leaves to help you map out the light and dark areas. Very lightly indicate the veins; once you're happy with the placement, knock them back with an eraser so the lines don't become muddied when you apply the masking fluid.

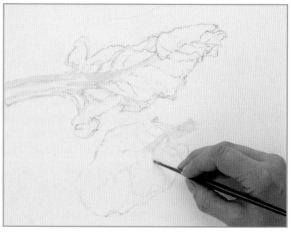

2 Using an old brush, apply masking fluid to the main veins and stalks of the leaves.

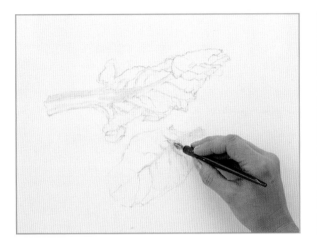

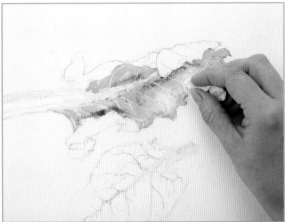

3 Complete the masking on the finer veins, using a fine-nibbed dip pen, twisting and turning the nib to create irregular lines, then leave the masking fluid to dry completely. Be sure to wash the brush and nib in warm, soapy water immediately after use.

4 Mix a mid-green from viridian and lemon yellow. Using a medium round brush, paint the light- to mid-toned greens, adding a touch of Prussian blue to the mix for the shadows around the central vein of the top leaf. Dab off paint with a scrunched-up piece of paper towel to bring out some highlights.

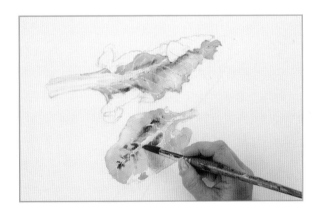

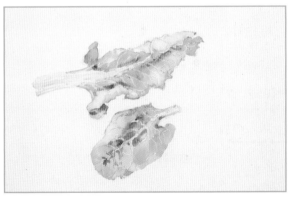

5 Paint the lower leaf in the same way, varying the proportions of the colours in the mix to create some tonal variation: the leaves are not a uniform, flat colour. Add a touch of alizarin crimson to darken the mix in places, and touch in neat Prussian blue, wet into wet, for the darker areas.

6 Continue layering the colours to create the density of tone that you want and build up some form on the leaves. Note that the undersides, where the leaves curl over, are more crinkled in texture and also more blue. Use a fine round brush to paint the shadow on the stem of the upper leaf in a mix of very pale viridian and burnt umber. Leave to dry completely.

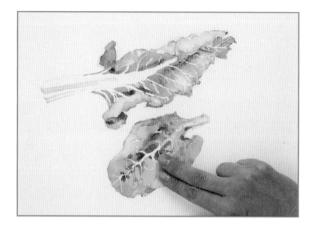

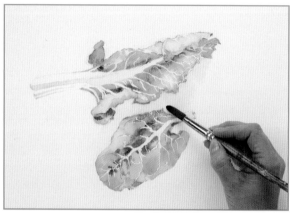

7 Using your fingers, gently rub off all the masking fluid.

8 Paint the central vein of the top leaf in a very pale mix of viridian and lemon yellow; some colour is reflected down onto it from the overhanging curled leaf. Touch in the cut, slightly brown ends of the stalks with a very pale mix of burnt umber and cadmium red. Mix a pale shadow colour from alizarin crimson and ultramarine blue. Wet the cast shadow with clean water, then drop the shadow mix into it, wet into wet, so that it spreads and blurs without leaving any obvious brush marks.

The finished painting

Without the use of masking fluid, it would have been almost impossible to preserve the very delicate, twisting white lines of the leaf veins. A second classic watercolour technique – wet into wet (see page 32) – has also been employed to good effect here, allowing the paint to spread and blur naturally, creating texture and tonal variations with no hard edges in the crinkled leaves.

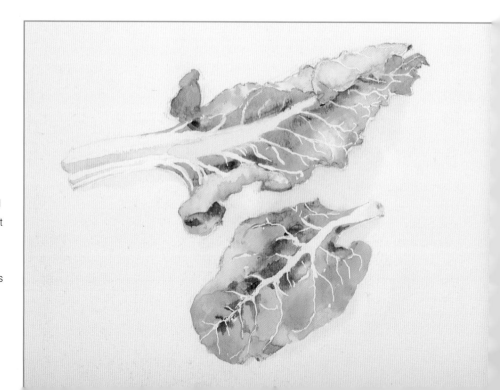

Mixing resist media

In addition to using masking tape and masking fluid you can also use 'grease' media such as wax or oil pastels. These exploit the natural antipathy of grease and water to create some interesting effects. They cannot be removed and should be used as part of your painting. Draw the shape of your subject with a wax crayon or oil pastel, or a candle if you wish the line to remain white, and then apply the watercolour paint over the top. The pastel or candle marks will repel the water.

The artist used several resist techniques in this moody, monochrome study. The windows of the distant cottage were drawn with masking fluid, while the rough textures of the foreground rocks were achieved by first applying strokes of candle wax to the paper. Sea salt crystals (see page 84) add texture too.

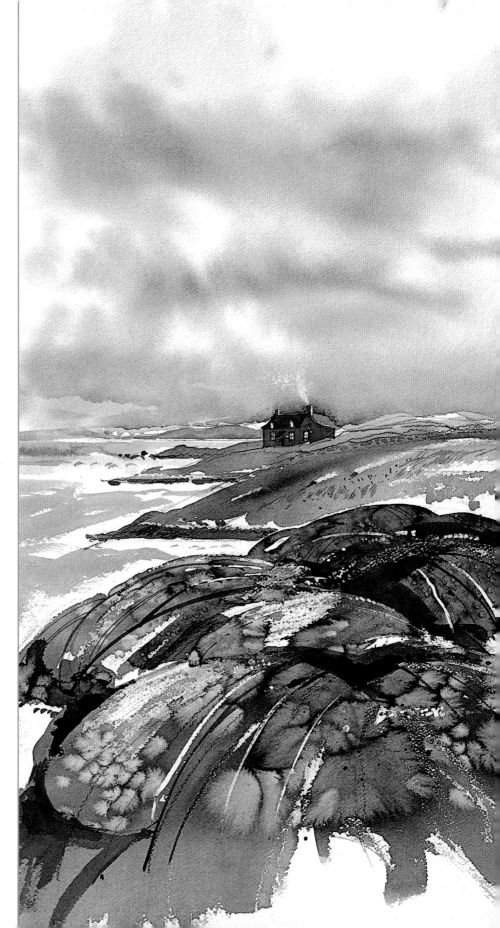

Spattering

There are two main ways in which you can use spattering techniques to add effects to your artworks: one is to spatter masking fluid (often used in landscape painting to create the effect of falling snow or water spray); the other is to spatter paint over the paper's surface.

Spattering is a way to add lively texture to a picture, with random splashes and speckles of paint. Spatters can be applied in a variety of ways, but it is essential to mask off or protect areas where spatters would be unwanted. Spattering can be applied wet into wet into a wash, but be prepared for the marks to spread and perhaps disperse completely. For clearer effects, work wet into dry. Use spattering for subjects such as the pebbles on a beach, close-ups of seed heads and grasses, speckles on fruit and flowers, and the pattern of an animal's fur or skin.

Spattering techniques

There are a number of ways in which you can spatter paint or masking fluid. You can load a toothbrush with paint and pull a palette knife, piece of plywood or card, or your thumb over the bristles so that they flick, or spatter, paint onto the paper in a random spray. The further away from the paper you hold the toothbrush, the wider the area you will cover. You get larger marks from a very wet mix of paint, and from spattering onto damp paper, as the paint specks will spread out.

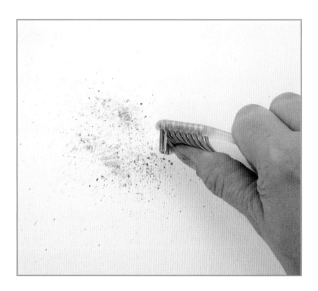

Spattering with your thumb
Using a broad, flat brush, apply paint to the toothbrush bristles. Then simply pull back the bristles of the toothbrush with your thumb. This method gives you a lot of control over the direction of the spray.

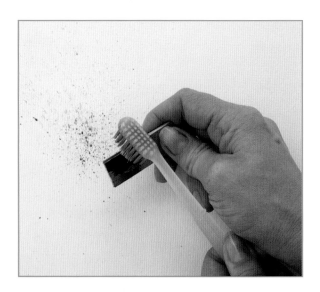

Spattering with a piece of plywood
Here, a piece of plywood is dragged over the bristles of the paint-loaded toothbrush.

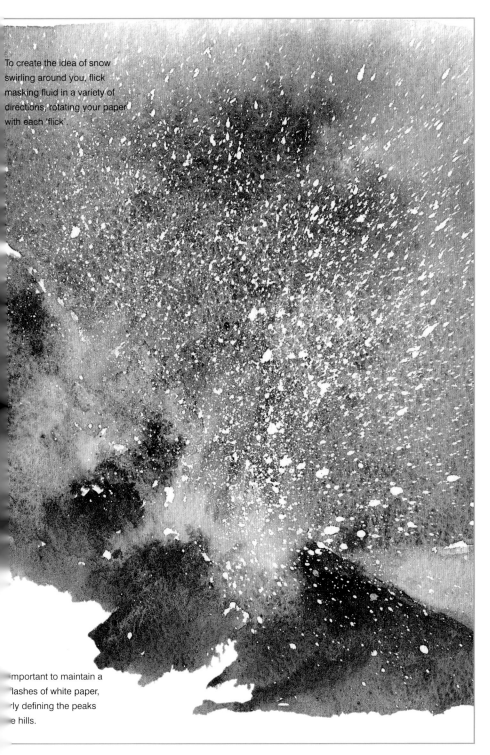

To create the idea of snow swirling around you, flick masking fluid in a variety of directions, rotating your paper with each 'flick'.

important to maintain a
lashes of white paper,
rly defining the peaks
e hills.

Spattering with masking fluid

Here we demonstrate how you can use spattered masking fluid to create the effects of a snow blizzard.

To create the effect of snow, dip an old toothbrush into some masking fluid and flick this onto the paper, creating a random coverage. Next, flood the sky or cloud area with water and immediately drop burnt umber, ultramarine, Payne's grey and raw sienna onto the paper – the colours will run and bleed on the surface water, creating a complex set of shapes and tones.

Then, add any appropriate shading to the foreground – this will rarely hold any colour in the middle of a storm, so a simple, pale grey will suffice.

When the paper is totally dry, gently rub the masking fluid, exposing the white paper left untouched by paint.

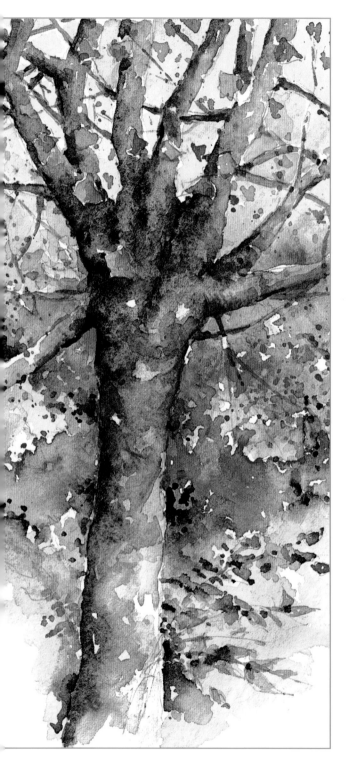

Spattering with paint

Spattered paint can be used in a number of ways. A light, even spray from a toothbrush held high above the paper is perfect for depicting sandy beaches; a heavier spatter from a more heavily loaded brush is good for pebbly or rocky terrains.

In the example shown here, spattered paint has been used to create an impressionistic effect of autumn foliage.

This sketch, looking deep into the forest leaves and undergrowth, owes its strength to the positive shapes of the leaves that can be seen in both the foreground and the background.

The underwash – a wet-into-wet wash of raw sienna, cadmium orange and cadmium red – was applied and then left to dry. The leaves in the background were created by flicking small quantities of paint – burnt sienna and cadmium red – carefully onto the dried underwash. This is a technique that requires a little practice to ensure that you can control the direction of the paint and the quantity applied, but it does produce a spontaneous and random effect that will help to create distant detail where only suggestion is required rather than a specific shape.

This seascape uses a variety of techniques, from wet on wet for the sky and cliffs, to spattering and resist techniques for the details of the pebbles and spray.

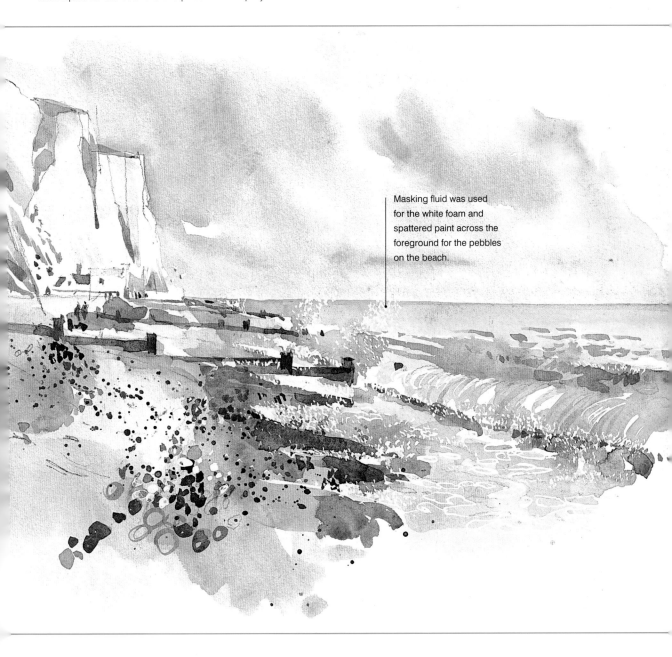

Masking fluid was used for the white foam and spattered paint across the foreground for the pebbles on the beach.

Sponging

Applying paint with a sponge rather than with a brush is a very simple way of creating texture and tone. A natural sponge is more randomly textured than a synthetic one and creates a more varied finish. The mottled texture produced by applying paint with a sponge is ideal for suggesting clumps of foliage or worn, weathered stone. You can try applying one colour on top of another, either wet or dry, to create interesting tonal variations.

Sponging may be done on wet or dry paper and over wet washes or ones that have dried. On damp paper, the marks will merge together. On dry paper, the marks are more sharply defined. If the paper is too wet, however, the sponge will not create a texture.

Sponging can also used to be 'lift out' excess paint, either to correct a mistake or to create a specific effect (see page 38).

Random, mottled effects can be achieved, but use them with restraint and not as a substitute for a brush. Here a natural sponge was used to portray the dimpled skin of a lemon, overlaying a darker wash wet on wet.

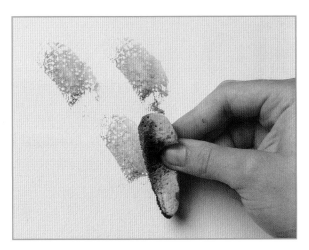

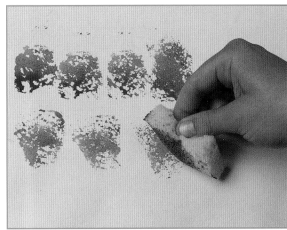

Natural sponge on dry paper

With a natural sponge, the result is coarsely textured, with the paint sticking like granules to the surface of the paper.

Synthetic sponge on dry paper

Dampen the sponge in clean water, squeeze it almost dry, dip it into paint and gently blot it onto dry paper. The result is textured but soft. Some areas of the paint dry to a crisp edge, while others blend into one another.

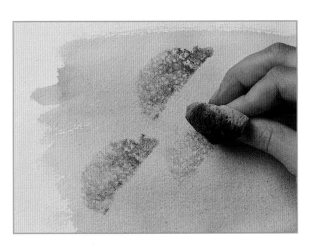

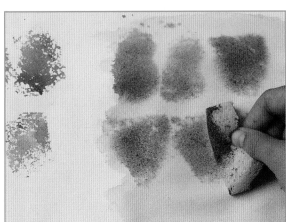

Natural sponge on damp paper

With a natural sponge, the result is softer than that of sponging on dry paper, but crisper than that of using a synthetic sponge on damp paper.

Synthetic sponge on damp paper

Paint a dilute wash over the paper. While it is still damp, sponge another colour of paint onto the paper, as before. The paint blurs and mingles with the underlying wash to produce a softer effect than on dry paper.

Stippling

Stippling is a technique in which dots of colour are applied to the paper with the tip of a brush. You can use just one paint colour to produce subtle gradations of tone, simply by altering the size and weight of each dot that you make, or you can combine different-coloured dots in patterns. The less space you leave between the dots, the denser the colour will appear. The technique is particularly effective for painting small textured objects such as pebbles and stones.

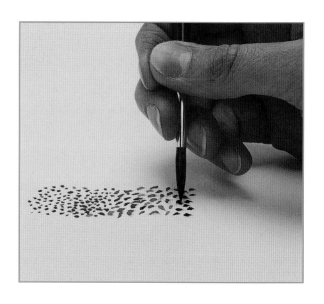

Repeat the exercise using a wetter mix of paint. The dots are not as sharply defined and the tone varies from one to another. There is also more variation in the size of the dots.

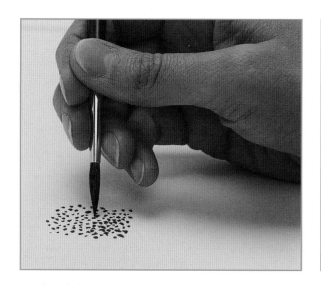

To produce even stippling, dip an almost dry brush into a thick mix of watercolour paint, making sure that you keep the bristles in a point. Hold the brush vertically and dot the surface of the paper, applying very little pressure.

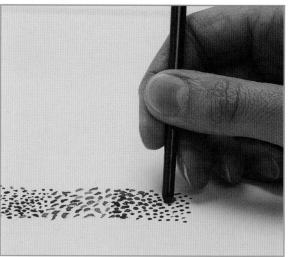

To produce flatter, more rounded and even results, turn the brush upside down and dip the end of the handle into a thick mix of paint. Quickly but firmly dot the handle down onto the paper.

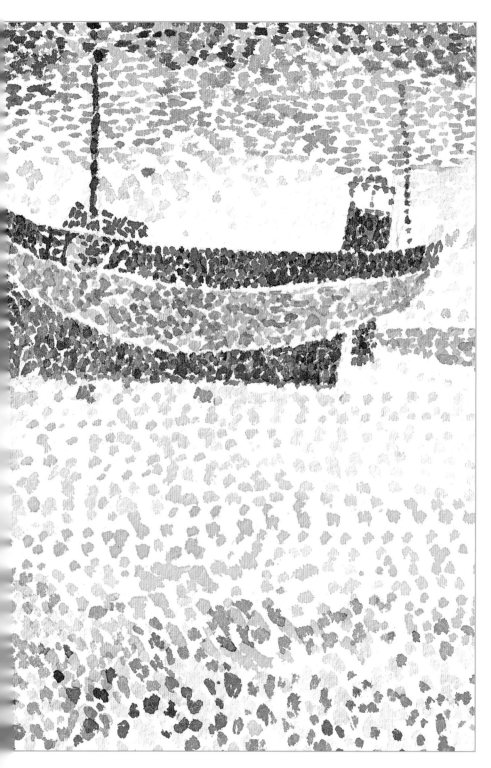

Effects of stippling

Broken colour is a form of stippling that is ideal for portraying dappled light or the sparkles of light on rippled water. When viewed from a distance, the colours merge in the viewer's eye, giving sparkle and luminosity. Broken colour can also be achieved by the dry-brush technique (see page 82), using one stroke of a wide flat brush with the minimum of pigment on rough paper.

Here the artist has used the contrast between complementary colours blue and yellow to simplify the image, combining dots of similar hues and tones to build up colour.

Drybrush

In this technique, paint is applied with an almost dry brush carrying very little paint to create crisply defined masses of lines. On rough paper, the technique creates a textured effect, with the paint marking only the bumps in the paper and leaving the troughs free of paint. On a non-textured paper, you will achieve a smoother look.

This technique is ideal for 'drawing' more linear details, such as furrowed fields, tree trunks or fence posts, or for adding areas of texture, to a shingle beach, for example.

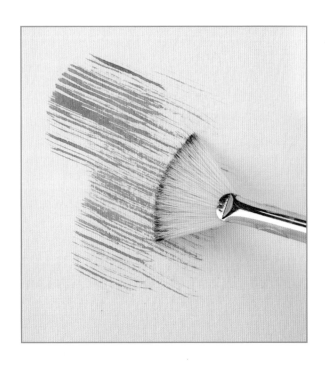

Dip a completely dry brush in reasonably thick paint, taking care not to coat it too heavily; you may want to wipe off excess paint on a piece of scrap paper or the side of the palette before you apply it. Drag the brush across the paper. Here, a fan brush is being used; you can achieve the same effect with a flat brush by splaying out the bristles with your fingers.

Here, the drybrush effect is used to pick out details in the palm trees and put a little texture into the sky and foreground.

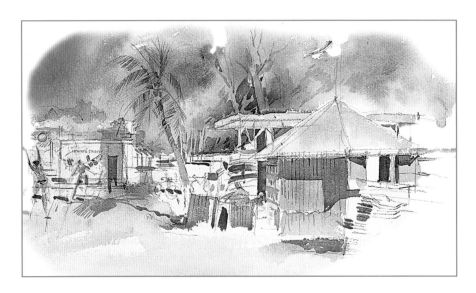

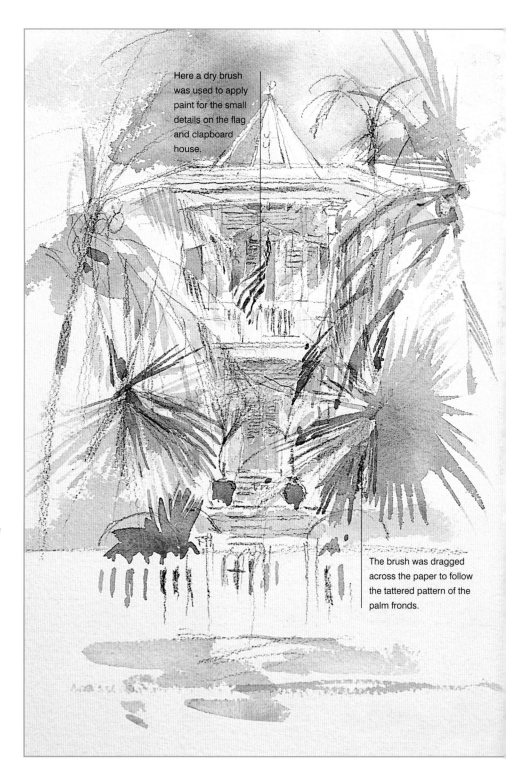

Here a dry brush was used to apply paint for the small details on the flag and clapboard house.

For this painting the artist used the drybrush technique to add both texture and to draw fine details.

The brush was dragged across the paper to follow the tattered pattern of the palm fronds.

Sgraffito and scratching techniques

The term sgraffito comes from the Italian word 'sgraffiare', meaning 'to scratch'. It involves scraping through a top layer of dry paint to reveal the underlying paper and is often used to create surface texture or highlights such as sunlight sparkling on water. Two common sgraffito tools are shown below, but you can use pretty much anything sharp – your fingernails, the tip of a paperclip or needle, or even a comb.

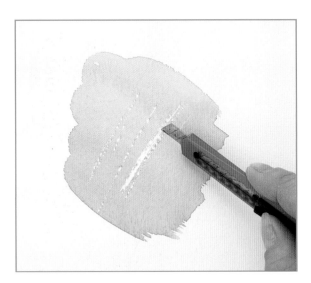

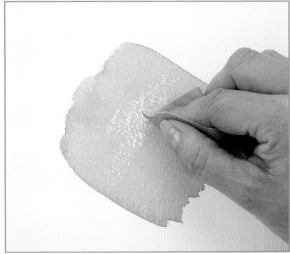

Sgraffito with a craft knife

This is one of the most popular sgraffito tools, as the point can be used to scratch out minute details and fine lines. Simply drag the blade across the paper, or use the tip to lift off small highlights, taking care not to dig too deeply and cut through the paper.

Sgraffito with sandpaper

Sandpaper is a useful tool when you want to work sgraffito over a wide area. Just drag or rub it over the paper surface, depending on how much paint you want to remove. Experiment with different grades to find out what effects you can create.

Sandpaper for sunsets

A small piece of fine sandpaper is perfect for gently rubbing away surface paint to create textural effects, and one common sgraffito application is removing paint from a skyscape to create a sunset effect. Note that with any sgraffito technique you will need to use fairly thick paper as less robust papers may not withstand the process.

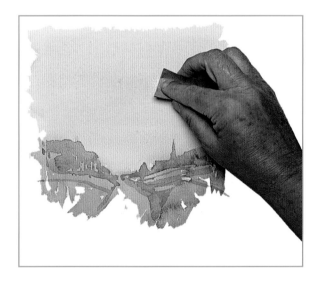

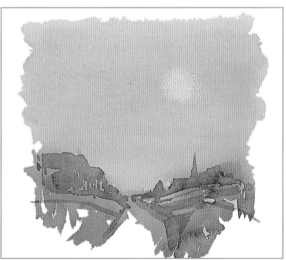

1 Lay a light wash of warm ochre for the sky. Mix some of the sky wash with a little sap green for the foreground trees and shrubs. Allow the paint to dry completely. With a small piece of sandpaper, gently rub an area of the sky in a circular motion to represent the setting sun.

2 Gently blow away any dust from the paper or lift it off with a soft kneaded eraser. The effect is of hazy, late-afternoon sun.

Adding texture to a wash

In addition to creating texture by distressing or spattering, you can make use of some natural effects, such as the texture of the paper and the granulation of natural pigments, to create a textured wash.

In addition, you can add substances to the wash if you wish to experiment further. Gum arabic or glycerine added to a palette of pigment, or even a drop of honey, will thicken the mix, enabling texture to be added with sgraffito techniques (see page 84). These mediums will also slow down the drying time. Other mediums are available from art stores, such as granulation medium, texture medium and blending medium.

Some effects to consider

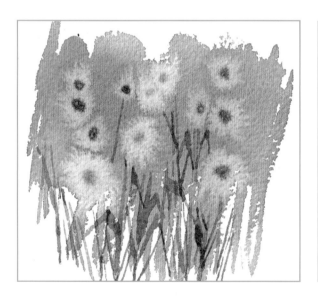

Salt crystals

Another natural, chemical reaction that can work to the artist's advantage is the effect of salt crystals – sprinkled over a wet wash they give an interesting, if random, texture. The salt will evaporate slowly and, when dry, it can be brushed off to leave flower-shaped, starburst marks. This technique can be applied to foreground detail, fabric textures or rock formations.

Gum arabic

This effect was created by applying gum arabic to the wash and then drawing through it with the end of a brush to create raised lines.

Texture medium

This example shows the effect of texture medium added to a wash of colour.

Granulation medium

You can exploit the natural granulation of some paint pigments – French ultramarine and burnt sienna, for example, leave tiny spots of pigment that coagulate as they dry, especially if undiluted. The combination of granulation medium and cobalt in this example has created a granulated effect in the wash.

Here the artist exploited the natural granulation of French ultramarine plus burnt umber to add interest to the sky in this simple pencil and wash study.

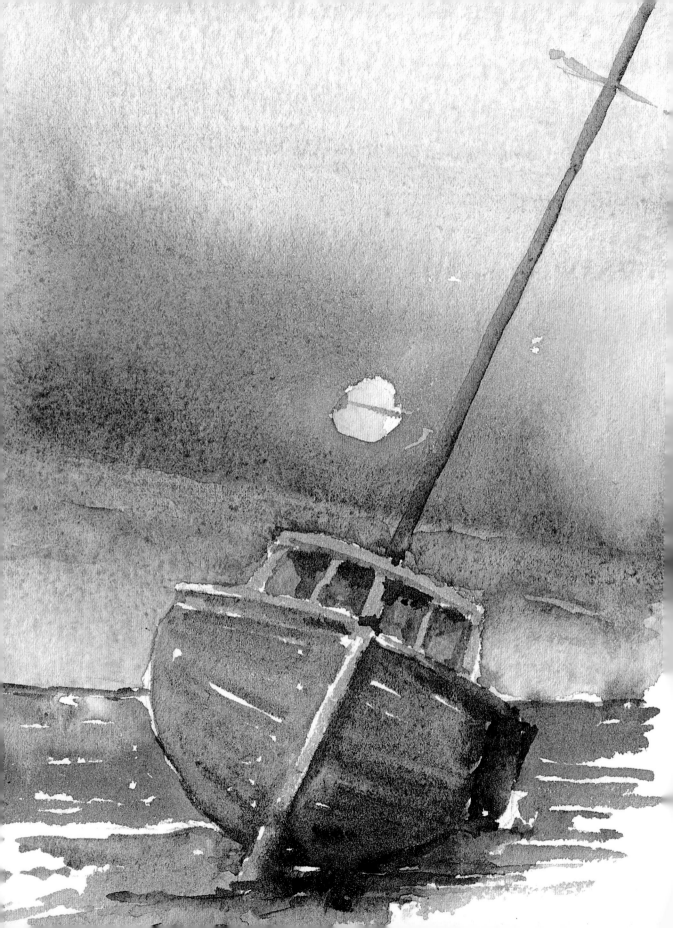

Watercolour Subjects

With some basic techniques under your belt, you can start to tackle the paintings you really want to create. In this section we give an overview of some of the most popular subjects in watercolour, from capturing light and shadows to portraits and still lifes, and, of course, a variety of landscapes.

Light and shade

In any form of painting, lights, halftones and darks are essential for conveying form. You can affect the mood and composition of your painting by controlling the light and shade that define your subject. Natural light is preferable for painting, but you will need to work quickly as the cast shadows will change as the sun moves. Alternatively, you can use artificial light in a number of different positions to achieve a variety of effects.

Direction of lighting

A sidelit subject will cast long shadows to one side. The side that is lit will be bright with strong highlights, in dramatic contrast to the shadowed side. A toplit subject will throw a short shadow beneath, with highlights on the top. A backlit, or *contre-jour*, subject will appear mainly in shadow, with soft diffuse detail, almost creating a silhouette with haloes of light.

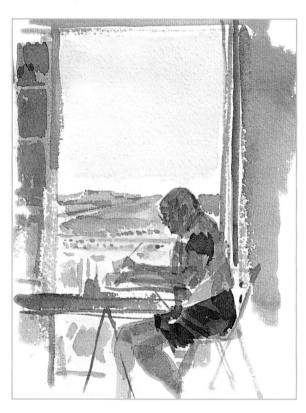

Side lit

In this example, the light is coming from the left, throwing long shadows out to the right and creating darker tones on the unlit side of the fruit, with brighter highlights where the light hits.

Top lit

A strong light directly overhead casts shadows immediately beneath the object, with bright highlights on top. In this example the light is also slightly behind the apples, throwing the shadows further forward.

Back lit

A figure placed in front of a light source, such as a window, is thrown almost totally into shadow, creating a virtual silhouette.

Capturing light and shade

The play of light across a landscape can often be the inspiration behind your painting, whether it be the dramatic contrasts of light and shade, the subtle effects of dappled light or an overall luminosity. Watercolour is the perfect medium for capturing the effects of light.

Before you start your painting, you need to assess the direction and intensity of the light. Making a monochrome, tonal sketch of the scene will help you to identify contrasts of light and shade and exploit them in your composition. Contrasts of tone work well in brightly lit landscapes.

Sometimes, the changes in tone are more subtle and the light appears more luminous. This type of light and shade, found in dappled sunlight through trees or on a hazy day, can be rendered using broken colour effects (see page 81) or by using the wet-into-wet technique (see page 32) to achieve soft transitions of colour and tone. Dappled sunlight under trees can be shown with a randomly applied wash, either wet into wet or wet on dry, over an existing lighter tone.

The intensity of the light will be affected by natural factors – the time of day, the season and the weather – and you should be aware of their different effects to render them accurately. All these factors will affect the colour temperature of the light: an early morning is generally cooler in tone than evening; a summer day is brighter than midwinter; rain clouds cast a cool shadow over a landscape.

This monochrome study conveys bright, dappled sunlight. The white of the paper creates a stark contrast with the dappled shadows thrown onto the wall, while the deep shadow seen through the open door establishes the darkest tone.

Painting shadows

Shadows are essential in any painting of light and shade, indicating the direction and intensity of light. To paint shadows effectively you need to look hard at the colours within them – shadows are never black but a muted version of the objects that they fall onto. The time of day also has an effect, as shadows will have different colour temperature values in the cool morning compared to the warmer tones of the evening. In intense light, the contrast between light and shadow is strong, shadows are clearly defined and the transition from one area to another is sharp. In hazy light, shadows are softer with less-defined edges.

Shadows contain reflected colour – from the sky, from the object casting the shadow and from adjacent areas of local colour. Add touches of complementary colours to your shadows. Start with primary washes to establish the undercolour and tone; the second wash will need to determine the strength of the shadow colour. This wash can be applied wet into wet or wet into dry. A good 'shadow' mix is ultramarine violet with burnt umber. A shadow thrown across an area of light green might be a mix of Payne's grey, viridian and gamboge.

Sometimes all you need do to throw an area into shadow is to apply a cool colour wash over the top, or you may find that you need to darken your original wash to achieve a shadow tone. A common error is to mix too strong a colour: remember that you are painting the interaction of light (and shade). An interior will show the tone values of shadows – a white wall is never white against the strong light from a window.

Materials

Arches rough paper 300gsm (140lb), sanguine
　　Conté pencil, squirrel brush, no. 5 round brush,
　　watercolour paints

The dappled light falling through the arbour of vines is the most striking element here. The intensity of the sunlight is conveyed through the short, dark shadows and the warmth of the surrounding tones.

1　Lightly sketch in the main elements of the composition using the sanguine Conté pencil. Search for the areas of light and shade and the tonal variations across the shadows. Apply a light wash of cerulean for the sky and place the shadows on the left-hand side.

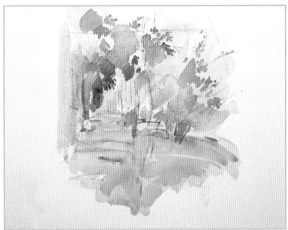

2 Mix a light wash of aureolin and apply this over the blue for the areas of bright light and highlights. Mix a warm wash of Naples yellow with a touch of light red for the foreground. Mix delft blue and raw sienna and drop this wet into wet for the foliage, taking the colour around the light of the focal point at the end of the covered path.

3 Continue to build the tones on the tree on the right and establish the warm tones of the foreground with the mix from Step 2, working wet into dry. Drop in touches of shadow colour mixed from ultramarine violet under the vine arbour and tree.

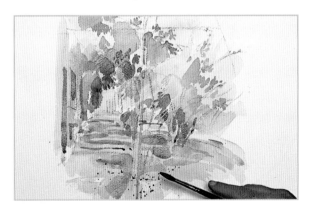

4 Build up the tones in the shadows with ultramarine violet and burnt umber with a thin wash of colour that allows the underlying glazes to show through. Start to delineate the main structures of the arbour and the building on the left, carrying the shadow colour into the recesses of the door and windows and building up the detail on the vines.

5 Mix a dark brown from ultramarine violet and burnt umber for the tree trunks and a burnt sienna and neutral tone for the wooden supports and the vines. Add the shadow beneath the tree on the right to help to anchor it to the ground and give the impression of a high, intense sun.

Buildings

Watercolour may not seem the most obvious medium for capturing the precise lines and shapes of architecture, but there are methods you can use if you want to tackle this fascinating subject.

Brush ruling

This is a technique that has only occasional use but can be helpful if you do not have a steady hand. By using a ruler to guide the brush, you can paint a straight line across your picture. Brush ruling is suited to architectural paintings where strong horizontals and verticals are required, or where the pattern of brickwork needs a regular line. You may wish to use it to represent the regular pattern of waves in a calm sea or for a painting that has a tighter, more controlled feel. This technique works best when applied wet into dry.

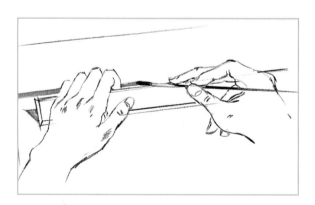

Hold the ruler raised slightly at an angle, using it to guide the brush, which is kept on the edge by the middle finger.

Resist techniques for controlled lines

If you want to make a precise study of a building you will most likely have to tackle creating controlled lines for details such as windows and doorways. This project examines the use of masking tape as one way to achieve this. The project also features other resist media – masking fluid for the flowers and candle wax for the mottled effect of the terracotta trough.

Materials

Arches rough paper 300gsm (140lb), HB pencil, masking tape, masking fluid, reed pen, candle, small squirrel brush, no. 8 round brush, watercolour paints

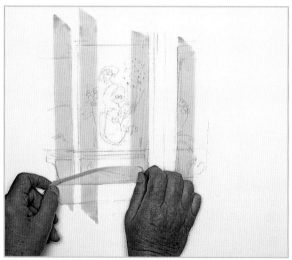

1 Lightly sketch the composition using an HB pencil. Mask off the dark shadows of the windowpane with strips of masking tape and trim off the excess in order to follow the shape of the windows.

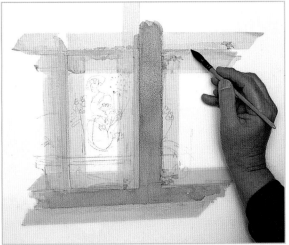

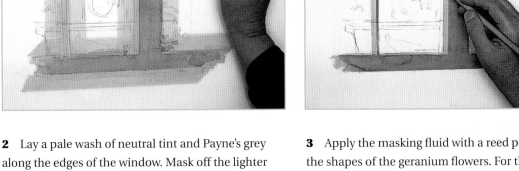

2 Lay a pale wash of neutral tint and Payne's grey along the edges of the window. Mask off the lighter areas of the recesses of the windowpanes, then apply a darker wash. Allow the paint to dry thoroughly before removing the masking tape.

3 Apply the masking fluid with a reed pen, 'drawing' the shapes of the geranium flowers. For the delicate gypsophila flowers, cover any areas that you wish to keep clear of spatters. then tap the reed pen over the paper to spatter the masking fluid in a random pattern. Shape the candle to a point, then rub across the plant trough to represent the mottled pattern of the stone.

4 Mix a light yellow-green wash from cadmium lemon and gamboge, and apply this to the background. For a richer leaf green, mix gamboge, cobalt and burnt umber and work wet into wet for the foreground foliage, adding the darks early.

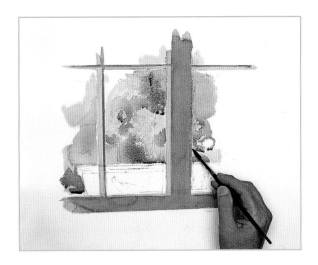

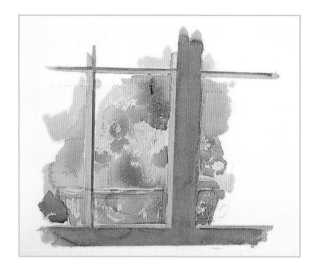

5 Mix light red, raw sienna and burnt sienna for the terracotta trough, with touches of light red mixed with sepia added wet into wet. The candle wax will repel the paint to reveal a subtle mottling effect.

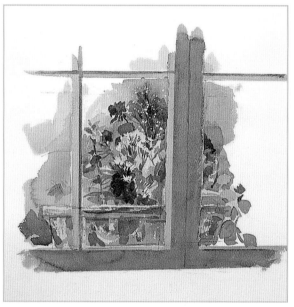

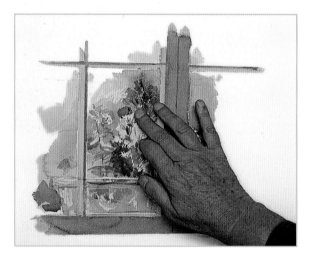

6 Mix a leaf green from raw sienna, cadmium lemon and cobalt and build up the pattern of the leaves. Use the negative shapes between the stems to establish the tracery of the foliage. Add touches of may green for the brighter leaves. Allow the paint to dry before gently rubbing away the masking fluid on the flowers.

7 Mix a rich wash of pure cadmium red with a touch of cadmium orange for the geranium flowers. Paint onto the white paper revealed by the masking fluid, this keeps the colours bright and zingy. Deepen the mix with a touch of alizarin crimson and apply this to the flower buds. You can strengthen the mix further by adding a touch of concentrated watercolour in rose.

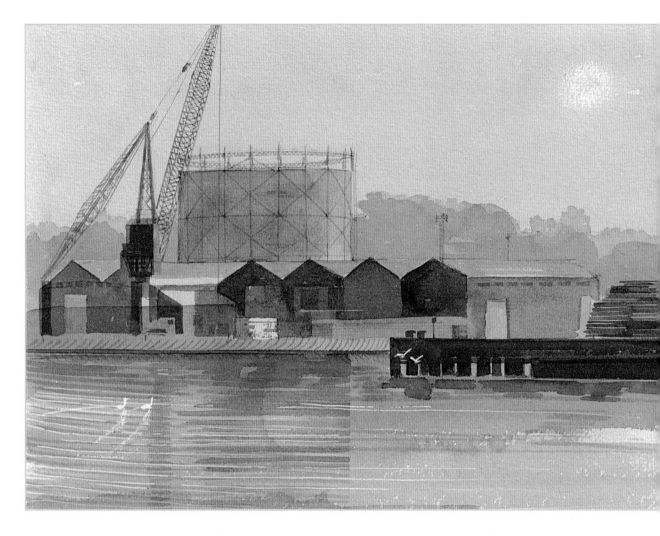

The muted hues of late evening light softened the stark nature
of these urban buildings, making a pleasing study with a quiet,
still mood.

Flowers

Flowers are a firm favourite with all artists. There are many ways of painting flowers, from highly defined and detailed botanical studies to a freer approach using techniques with broad brushes and wet-into-wet marks for looser interpretations. However, generally you will want to convey the shapes and colours of a bouquet and this involves searching out nature's geometry.

Make pencil studies of different flower heads, petals and leaves. You will notice that circles, cones and ovals are common and they can be used as a generalized shape on to which you can add detail. Lightly draw a circle or an arc to follow the extent of the petals and paint within this line to follow the natural symmetry of the open flower.

Many watercolour techniques are suited to flower studies but you will need to add some different colours to your palette, in order to capture their vibrancy. For still lifes, use a darker background tone behind the flowers to help throw them forward and enhance the flower shape.

Sunflowers are delightful subjects. The flower heads are symmetrical, with bursts of colour in the petals and strong, graphic leaves. Here the artist used a dark background to highlight their shape, painting wet into dry to retain crisp outlines.

In this study of anemones, the wet-on-dry technique allows the individual flower heads to stand out from each other and from the background, creating a colourful and vibrant still life.

Portraits

For an accurate portrait, you need to have a basic knowledge of anatomy and the proportions of the head. Think of the head as egg-shaped, with a vertical axis for the centre of the face and horizontal axes for the eyes and mouth. These structural lines become elliptical when the head is turned.

The proportions of the head are divided into three segments: the hairline to the eyebrow; the eyebrow to the tip of the nose; the tip of the nose to the bottom of the chin. Another useful measure is to place the eyes halfway and the mouth halfway between the tip of the nose and the chin. The corner of the eye is level with the top of the ear.

Lighting is an important factor to consider, together with the pose. A backlit portrait will add drama to the picture. A portrait need not be simply head and shoulders, of course – full-length, seated or three-quarter views are all options.

A portrait is not just about achieving correct facial features: you need to aim to capture something of your sitter's character, too. You can do this with props that relate to personal interests, clothing and the setting. Talk to your sitter as you paint and you will be rewarded with a relaxed and animated expression.

Materials
Smooth hot-pressed paper 300gsm (140lb), 5B pencil, no. 8 squirrel brush, rigger brush, watercolour paints

For this relaxed portrait the artist combined pencil and wash, using a fine brush to draw the sitter's striking facial features once the initial wash had dried.

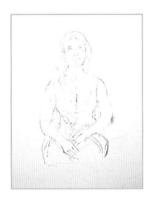 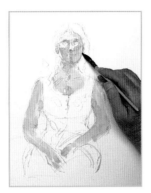 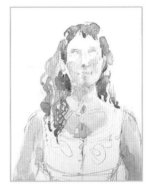 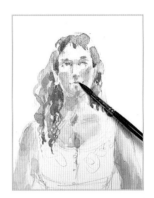

1 Lightly sketch the outline of the figure with a 5B pencil, starting with the head and hair and then the shoulders. Find the centre of the face and add the position of the eyes, then the nostrils and mouth. Lightly shade the tonal areas, such as beneath the eyes and under the cheekbones, to establish the light source and give form to the face.

2 Mix a thin wash of light red and raw sienna for a warm skin tone and apply to the whole figure, leaving a few highlights. Apply a darker, denser wash beneath the chin, nose and cheeks and continue this colour down the arms. Add a touch of alizarin to the face for a warmer tone to build form.

3 Apply an underwash of burnt umber and light red to the hair, using loose, wavy lines to follow the pattern of the curls. The shape of the hair helps to outline and give form to the face.

4 Use a light wash of terre verte on the face, adding burnt sienna to build a darker skin tone. Build up another tonal layer on the hair using a mix of ultramarine, raw umber and burnt umber. Add details to the eyes to indicate their position and the direction of the model's gaze.

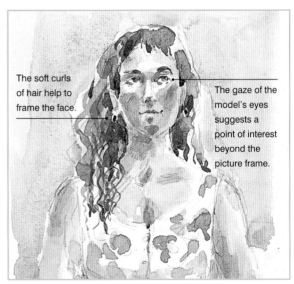

The soft curls of hair help to frame the face.

The gaze of the model's eyes suggests a point of interest beyond the picture frame.

5 Continue to work over the entire figure, building shadows under the chin and along the cleavage. Add shadows on the light-coloured dress with a wash of terre verte, following the natural indentations and shape of the body to give substance to the figure. Add the pattern on the dress with suggestions of colour. Finalize the curls of hair using a rigger brush. Finally, apply a light wash of raw sienna to the background around the figure to place it in context.

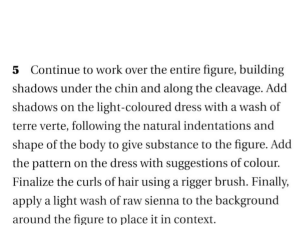

Skies

Watercolour is very popular for depicting evocative outdoor and landscape scenes, and therefore it is a good idea to have a few ideas and approaches to painting atmospheric skies in your repertoire.

Skies present myriad shapes and colours depending on the type of cloud formation, the light and time of day. Sketch different cloud effects to familiarize yourself with their characteristics and decide on your painting technique. In any skyscape, the sky and land should relate to each other, with similar values of light. To help establish a link, lay a toned wash across both the sky and land at the start of the painting and use some of the sky colour in the landscape as you work. When planning a skyscape, consider the position of the horizon; a low horizon will give dominance to the sky, whereas a high horizon will create a more intimate sky.

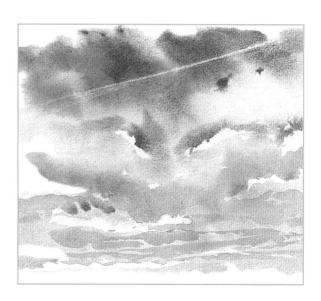

Here, the sky fades from a strong cobalt blue to a pale violet along the horizon, tinged with raw sienna. The white of the cumulus clouds was achieved by leaving the white of the paper to represent the tops.

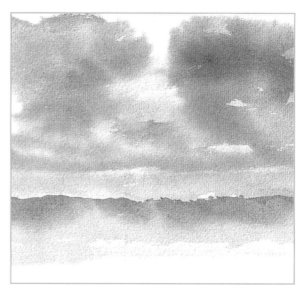

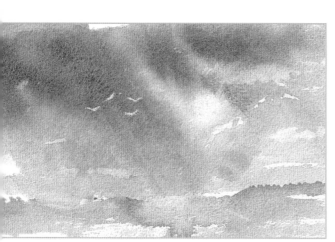

This simple sky study was painted wet into wet using Payne's grey, indigo and raw sienna. The birds, and the vapour trail in the sky below, were created using sgraffito (see page 84).

This rain-laden sky with low stratus clouds is a mix of cobalt, cerulean, raw sienna and a touch of alizarin crimson. The colours were dropped wet into wet and left to blend naturally.

Materials

Arches rough paper 300gsm (140lb), no. 8 squirrel brush, watercolour paints

You can achieve an effective sky study with a few simple washes. 'Draw' with the wash to use the white of the underlying paper to represent clouds.

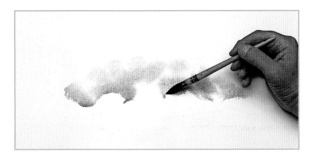

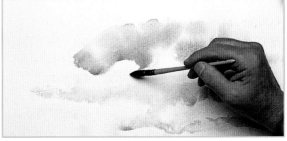

1 Float clean water onto the paper, leaving a few dry areas of white paper for the clouds. Mix a large wash of cobalt blue to make a fairly thin colour. Working quickly, build the wash around the tops of the clouds, softening the edges slightly. Apply more of the wash in narrowing layers toward the horizon.

2 While still wet, mix a wash of either Naples yellow or raw sienna and apply just below the tops of the clouds to represent the sun hitting the higher areas.

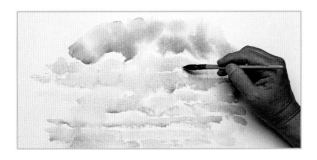

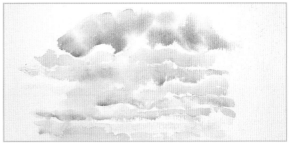

3 Mix a neutral shade from cobalt blue and alizarin crimson with a touch of burnt umber. Gently apply this to the wet areas underneath the clouds and along the horizon.

4 The impression of depth is achieved by the receding clouds and the pale tones towards the horizon.

Water

As with skies, water is an element that will often feature in your landscape scenes. Over the next few pages we offer a few ideas and techniques that will help you to convey water in different moods and contexts.

Painting reflections

The nature of reflections depends on the water surface – from a mirror image on still water to distorted shapes on a rippled surface. The colour of the reflected image should be darker and muted, and its shape softer. Look for other colours too,

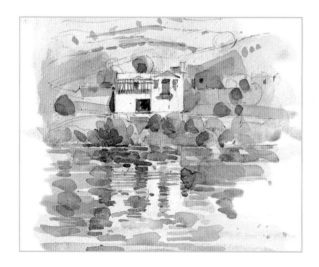

The reflection of this building has been distorted by the ripples on the water surface; only a subtle suggestion of the white façade is discernible. The colours of the reflected trees and bushes along the shoreline are slightly muted tones; their soft, blurred edges are rendered wet into dry over the ripples of the water's surface.

such as those of the sky and passing clouds.

A reflected image in still water will be seen directly beneath the object, following the same proportions. Objects further away from the water's edge will not be reflected to their full height.

An image reflected in rippled water will be fragmented and its shape will become faceted. The effects of broken colour can be used to make horizontal brush marks simulating movement in water reflections. The wet-into-dry technique is suited to painting reflections, giving you control over the shape of the image.

Conveying transparency

The transparent nature of watercolour paint makes it ideally suited to water studies. But to give the impression of looking into water you need to carefully observe the different elements before proceeding. For example, looking into a rock pool you will see reflections, light on the surface and the shapes of the objects below the surface. Any ripples across the surface will make the objects beneath appear distorted and larger. Refraction causes shapes to change beneath the water surface and you will need to note this carefully.

The transparent nature of water can be conveyed with a simple wash over the top of the objects below. Keep colours clean with just one or two glazes. To give the impression of light reflecting off the surface, use sgraffito or masking fluid to suggest sparkles and highlights.

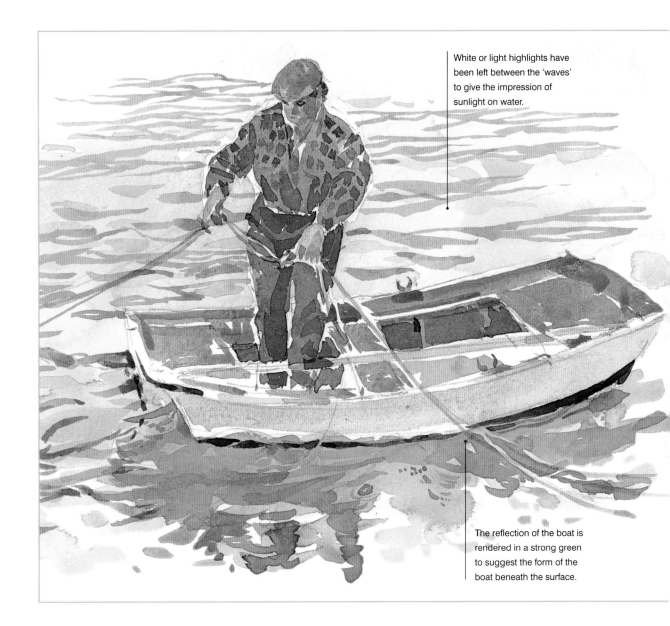

White or light highlights have been left between the 'waves' to give the impression of sunlight on water.

The reflection of the boat is rendered in a strong green to suggest the form of the boat beneath the surface.

Broken water

To convey broken water, start by dampening the paper and then, working quickly, apply the appropriate colour wash, pulling the paint downwards with confident and decisive brushstrokes.

Once this first application of paint has dried completely, use a small brush and a limited set of dark paints to describe the movement on the surface of the water. Because the colours that you will see underneath overhanging branches, bridges, boats and so on are actually the colours of the objects being reflected, this should be your starting point.

Choose the darkest of these colours, mix a little of your main water reflection mix to harmonize the colours, and paint a thin line that echoes the shape and direction of the ripple. Then, using plain water, wash the bottom edge of the brushstrokes out into the paper to prevent a hair line forming and to give a more natural look to the ripple. Repeat this process a few times, at all times ensuring that your brushstrokes follow the natural curve of the ripples and that the spaces between them expand towards the bottom of your picture.

For gently moving water, add the detail of the directional movement of the water only when the reflections are dry.

The key to painting successful ripples is to make some judgements about the depth of tone (ripples are often only moving reflections) and the spacing between them – not too many, and not too evenly spaced. Always remember that ripples spread outwards in a rhythm, expanding as they go.

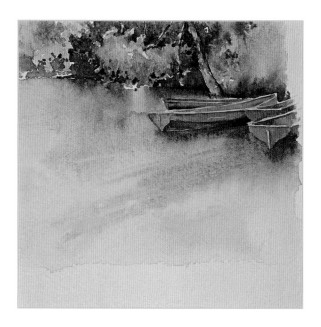

1 Create the colours by mixing a diluted version of the overhanging trees.

2 Mix the underside of the boat with the colour of the water and draw a thin line.

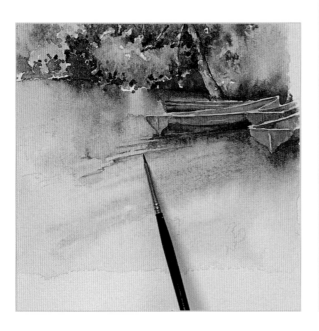

3 Wash the underside of the line into the underlying colour to avoid a hard edge.

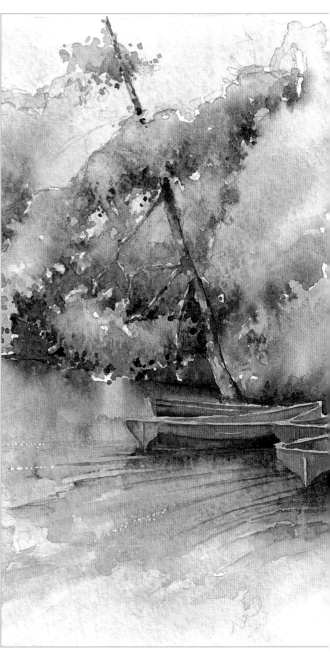

4 Don't worry about watermarks occurring in your reflections. They can often work to your advantage, suggesting the shapes of trees and bushes in water reflections.

Moving water

As water tumbles across rocks and boulders and breaks around them, areas of white water appear – and it is these areas of white that give a convincing impression of moving water in a painting. In watercolour, the best way to convey this is to leave areas of white paper showing as you paint around rocks and boulders. The more white paper you leave, the faster the water appears to be moving.

When you make notes to determine the white water, hold your pencil lightly and work with short marks. You can also scratch into dry paint with a sharp blade to create the effect of sunlight sparkling on water.

The key to painting moving water successfully is to look at the shapes the white water makes as it breaks around rocks – it rarely, if ever, flows in a completely straight line. You may find that it helps to make a few faint pencil marks to remind yourself which areas to leave unpainted.

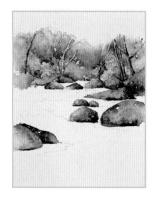

1 Fill in the background and foreground rocks and boulders, leaving the water area free of paint.

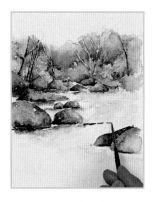

2 Paint the water area, leaving spaces around the boulders and several lines of water movement.

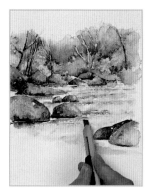

3 When dry, scratch off tiny flecks of paint with a sharp knife to represent light bouncing from breaking water.

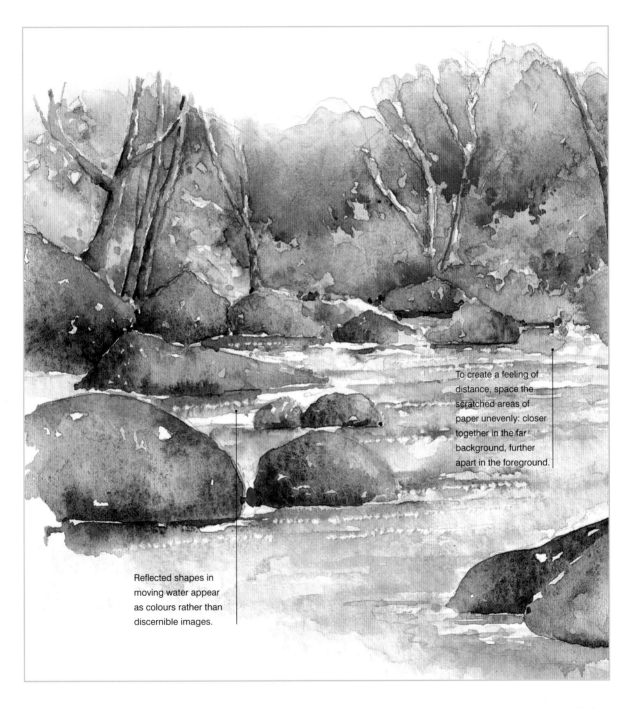

To create a feeling of distance, space the scratched areas of paper unevenly: closer together in the far background, further apart in the foreground.

Reflected shapes in moving water appear as colours rather than discernible images.

If you want to record moving water, try to create a 'snapshot' image of the scene in your head, and then use fluid marks to record this image on paper.

Tumbling water

Even though this waterfall is quite small compared with many that you might encounter, the water was tumbling across the rocks and boulders with enough force to create a series of large splashes as little droplets of water flew outwards across the scene. Capturing this in a painting invited the use of masking fluid (see page 70) to create the splashes and droplets.

Materials

300gsm (140lb) watercolour paper, 1 large (no. 12) brush, 1 medium (no. 8) brush and 1 small (no. 2) brush, old toothbrush, masking fluid water container, watercolour paints

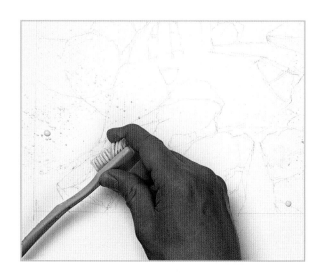

1 The first stage of this painting is to dip an old toothbrush into a saucer of masking fluid and flick the fluid up across the paper following the direction of the water spray.

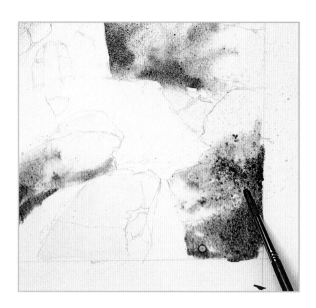

2 Once this has dried, apply an underwash of raw sienna to wet paper with a large brush. While still damp, flood burnt umber and cobalt blue mixes onto the darkest rocks.

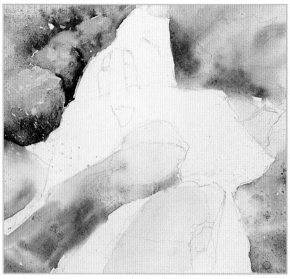

3 The grass area of the water's edge is painted onto the raw sienna underwash. Create a little definition by drawing onto the rock shapes with a small brush and a very dark tone.

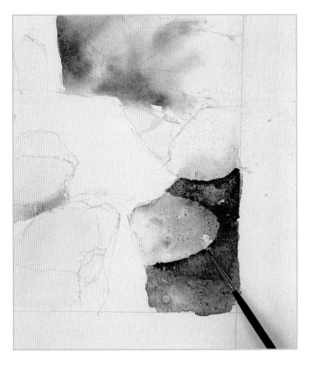

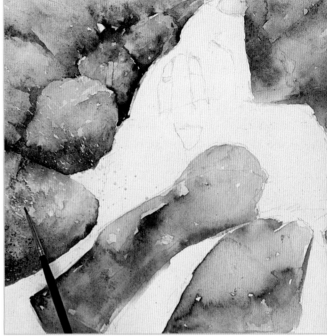

4 Using a small brush, add texture to the rocks by dropping pure earth colours onto wet paint, one after the other in rapid succession. This allows the paint to create its own mixes, which dry at different speeds, creating a sense of texture.

5 This process is continued across the rocks, working carefully around the white sections of water. Apply burnt sienna, raw sienna and raw umber wet, and allow them to dry unevenly.

6 Moving on to the rocks in the middle, add a little cobalt blue to darken the tones, ensuring that the darkest sections are those low down at the waterline.

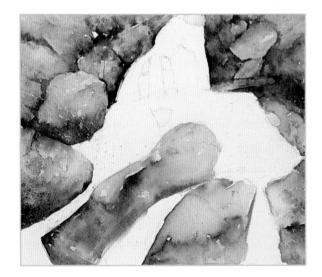

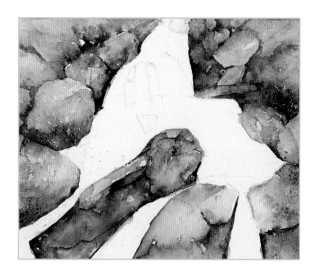

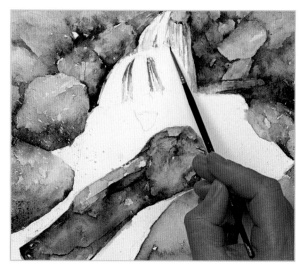

7 Working carefully, add texture to all the rocks, and then use a small brush to sharpen up any lines or ridges with the darkest of colour mixes.

8 For the water, use a small brush and very diluted version of the rock colours already in the palette to paint some of the areas of rock visible through the water.

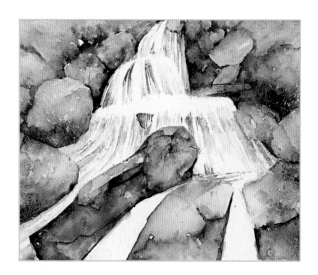

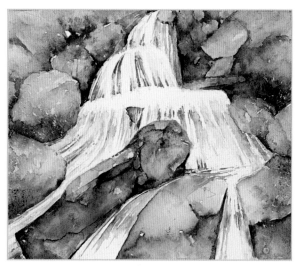

9 Working downwards, carefully follow the direction of the flow of the water around and across the rocks. The less paper you apply paint to, the faster the water appears to be flowing.

10 The water in the immediate centre foreground was the darkest as it flowed underneath an overhanging boulder – make confident one-stroke applications with a small brush using the darkest of tones.

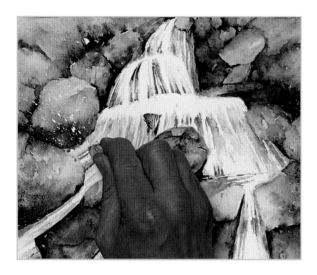

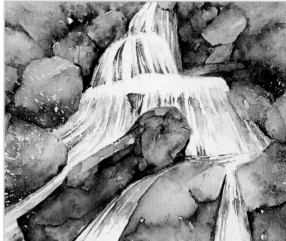

11 Once all the paint has thoroughly dried, remove the initial spattering of masking fluid by gently rubbing over the surface of the picture with a putty rubber. The paint must be completely dry, or the rubber will smear it.

12 The final stage of this painting involves using a small brush to sharpen up the edges on a few boulders, carefully avoiding any of the pure white paper that is revealed by removing the masking fluid.

The feeling of power, energy and movement in this painting is largely the result of a vigorous application of masking fluid to create the spray, and strong, directional brushstrokes along the line of the water flow. The close-up framing of the picture also contributes to the sense of movement that is present within the scene.

The darkest tones and rock detail are drawn onto the underwash with a small brush.

Directionally spraying masking fluid helps to establish a feeling of movement and energy.

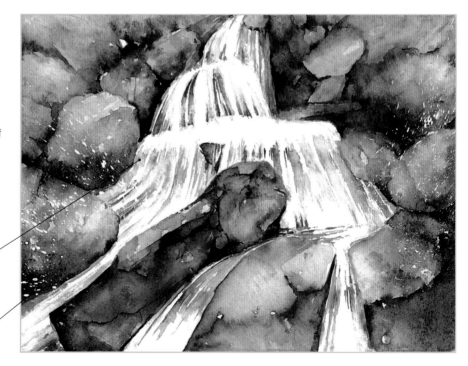

Seascapes

Landscapes of all descriptions provide countless opportunities for experimenting with textural techniques of the sort reviewed page pages 66–87. The soft texture of mosses and lichens can be conveyed with sponging; small pebbles and sand by spattering paint; and cracks and crevices in rocks by scratching into the paint with a sharp-tipped implement.

The most important thing is not to lose sight of the landscape as a whole: texture is only one aspect of your painting and textural techniques should not be allowed to dominate.

The scene

The rocky shoreline and the line of orange lichen-covered rocks on the left both point in towards the focal point of the image – the castle on the headland – while the relatively low viewpoint adds drama to the composition.

Materials

Not watercolour paper, 3B pencil, masking fluid, old brush for masking, mop, large and small round, and small flat brushes, wooden cocktail stick, small piece of natural sponge, cotton bud, newspaper, old toothbrush, paper towel, watercolour paints

1 Using a 3B pencil, lightly map out the main sweep of the composition, putting in the horizon, shoreline and the castle on the headland. Put in the main lines of the foreground rocks so that you can use them as a guide later in the painting: don't draw every single one, but put in just enough to indicate the directional lines of the various strata.

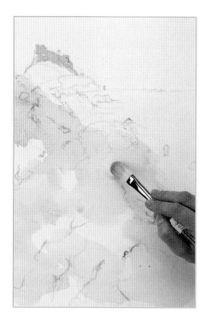

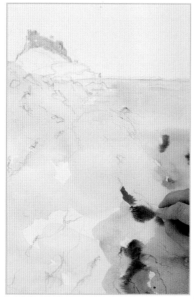

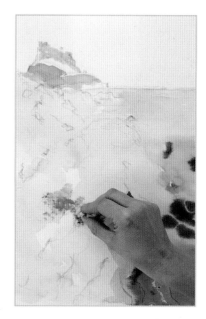

2 Using an old brush, mask out the castle on the headland and leave to dry completely. Mix a pale purplish-brown from alizarin crimson, raw umber and ultramarine blue. Using a mop brush, wash the colour loosely over the foreground rocks, adding a little more ultramarine when you get to the water-covered rocks right on the shoreline.

3 Using a large round brush, apply a wash of ultramarine and Prussian blue over the sea, using horizontal strokes to echo the flow of the waves. Add alizarin crimson to the mix as you get down to the foreground water. Brush burnt umber loosely over the foreground rocks, then touch a mix of burnt umber and ultramarine into the darker side of the rocks to suggest their rounded shape. Using a wooden cocktail stick, draw into the wet paint, pulling out a fine, squiggly line to suggest some of the cracks and crevices in the rocks.

4 Mix a muted green from cadmium yellow and ultramarine with a hint of burnt umber and brush in the grassy area on the headland. Dip a small sponge into the mix and dab it onto the foreground rocks to give an impression of lichen.

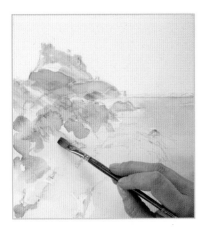

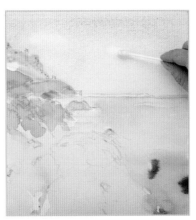

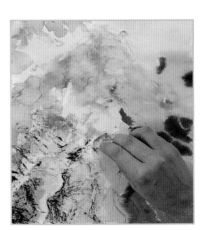

5 Mix a reddish brown from cadmium red, burnt umber and a little cadmium yellow. Using a small flat brush, paint the rocky headland on which the castle sits and the slabs of rock in the top left of the image. Mix a dark purple from ultramarine blue, alizarin crimson and a little raw umber and paint the shaded sides of the rocks.

6 Mix a bright blue from ultramarine and Prussian blue and paint the sky. While the paint is still wet, use a cotton bud to lift off some of the colour and create cloud shapes.

7 Mix a dark blue from ultramarine blue and raw umber and wash it over the rocks in the middle distance. While the paint is still wet, draw into it with the cocktail stick to create some of the cracks and crevices. Mix a dark blue-black from alizarin crimson, Prussian blue and burnt umber and, using a small round brush, put in the darkest crevices in the foreground rocks. Scrunch up a piece of newspaper, dab it into the same mix, then dab it randomly onto the foreground rocks to create some texture.

8 Mix a dark brown from burnt umber and ultramarine blue and, using a small flat brush, scumble in the dark, shaded sides of the rocks in the middle distance, so that you begin to develop some form. Don't overdo this area; it's important to keep the bulk of the textural work in the foreground in order to keep a sense of the scale and perspective of the scene.

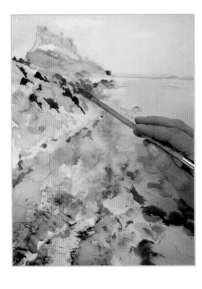

9 Add a little permanent white gouache to the previous blue-black mixes and apply to the foreground rocks to intensify the washes and build up some form in this area.

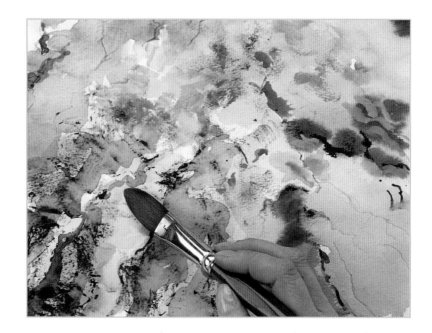

10 Drybrush a thick purple mix of alizarin crimson and ultramarine over the left-hand edge of the sea to suggest ripples as the waves approach the shore. Note how the white of the paper suggests sunlight sparkling on the water. Use a small round brush and the same purple mix to put in some rounded shapes in the water near the foreground to suggest submerged rocks. Mix an opaque mid-toned brown from lemon yellow, permanent white gouache and burnt umber, and dab and spatter this mixture over the shoreline for the lighter-coloured rocks.

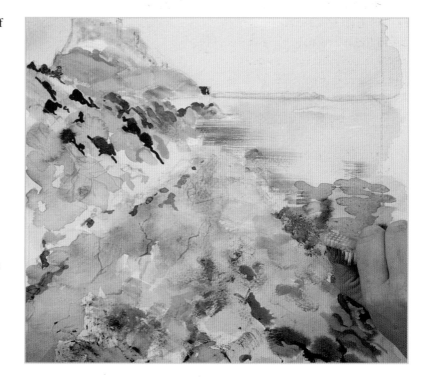

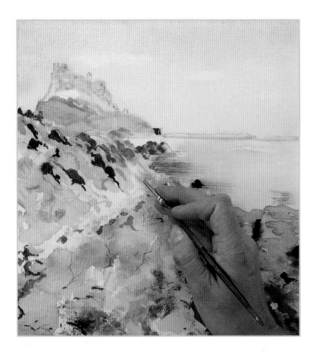

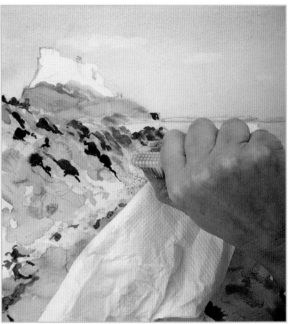

11 Add permanent white gouache to the previous mixes and apply small strokes of colour to build up the light facets of the rocks in the middle distance.

12 Rub off the masking fluid. Place a piece of paper towel over the foreground rocks and spatter the dark purple mix from step 10 over the base of the rocks in the middle distance to create the impression of small stones.

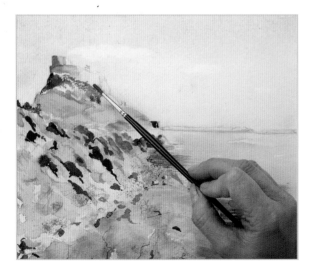

13 Mix a very dilute orange from cadmium red, burnt umber and a little lemon yellow and brush it over the whole of the castle. Leave to dry. Paint the shaded side of the castle with a purple mix of ultramarine, alizarin crimson and burnt umber.

The finished painting

Several textural techniques have been used in this painting – sponging, spattering, sgrafitto with a wooden cocktail stick, drybrush work and applying paint with scrunched-up newspaper – yet none has been allowed to dominate the image. Note how the bulk of the textural work is confined to the foreground; this helps to establish the different planes of the image and give a sense of distance, as the eye assumes that any textured areas are closer. Tones, too, are darker in the immediate foreground. The result is a light, airy depiction of a coastal scene.

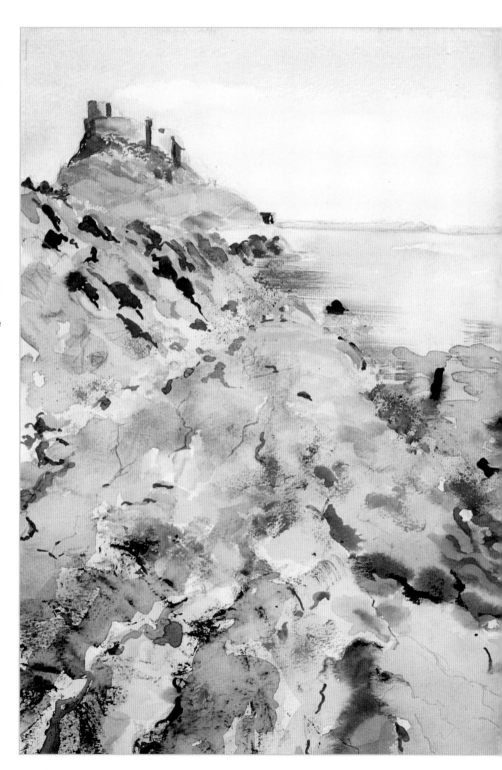

Calm summer scene

One of the great joys of watercolour painting is that it is perfectly possible to pack up a portable kit and paint outdoors. This serene view of a sunny landscape might be just the subject to inspire you to set up outside.

The peace and tranquillity of the backwood scene in this project was as much due to the soft tones of the sky as the gentle stillness of the trees and the calmness of the foreground.

It was important that the sky and foreground shared a major unifying factor. To link the two areas, raw sienna featured in the clouds and also as the underwash for the trees and hillocks in the foreground.

Materials
425gsm (200lb) watercolour paper, 1 large (no. 12), 1 medium (no. 8) and 1 small (no. 2) brushes, watercolour paints

1 The first stage of this painting is to dampen the paper (not flooding it) to allow the first wash of ultramarine to bleed gently down into the sky areas, creating very soft edges in the process.

2 Before this can dry fully, add a very thin wash of raw sienna to the base of the clouds and allow this to bleed upwards to add a little 'weight' and warmth.

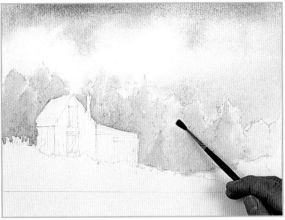

4 To start to develop the colours in the trees, apply a wash of olive green – a soft, thin colour – onto the damp underwash, allowing the paint to create some shapes in the foliage.

3 Next, apply a stronger wash of raw sienna to the line of trees in the middle ground. This may bleed a little into the sky – but this is welcome as it softens the tops of some of the trees, which is in keeping with the atmosphere of the scene.

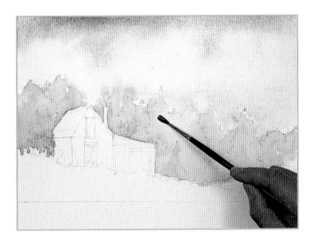

5 Again, working quickly onto damp paper, use a small brush to drop some cadmium yellow onto the tops of the trees, reinforcing the light from the summer sky catching the highest points of their boughs.

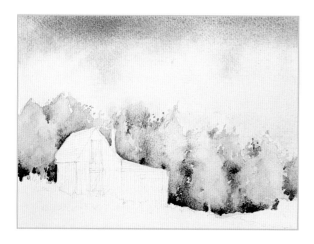

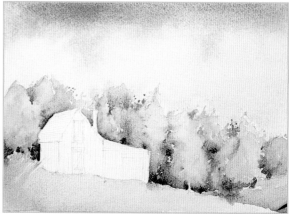

6 With the main 'underwash' now complete, start developing the deepest tones to push the lighter ones forward. Using a small brush and a mixture of sap green and ultramarine, work along the base of the trees where the deepest shadows would be.

7 With the middle ground now complete, you need to establish an underwash for the foreground. Apply a raw sienna wash to damp paper, then, using a gradated wash technique, pull olive green upwards from the base of the paper and allow it to dry.

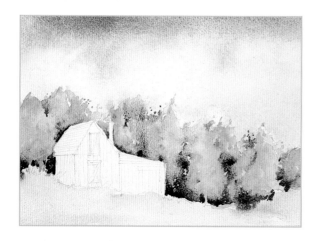

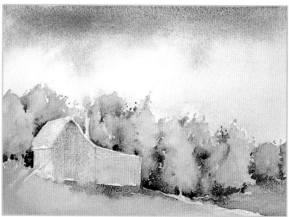

8 The two hillocks should be defined using the darker green mixture (sap green and ultramarine) to paint the furthest one. This is one of the few times in this project when hard lines can be encouraged.

9 With the foreground dry, careful attention can be given to the shadows cast by the warm summer sky. Mix these with ultramarine and alizarin crimson and paint them across the cabin and the foreground.

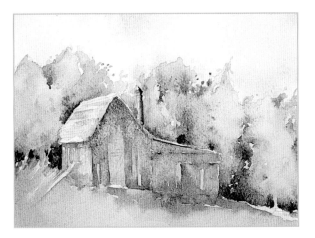

10 The final stage is to complete the detail on the cabin using a mixture of ultramarine, burn umber and burnt sienna, reinforcing the ultramarine and alizarin crimson in the process.

The softness and warmth of both sky and ground is achieved by choosing the right colours for the job – ultramarine for the main sky colour, and an underwash of raw sienna. The lack of movement in the sky, suggesting a calm, windless day, is created by allowing the paint in the sky to find its own way on damp paper and by not introducing any directional brushstrokes.

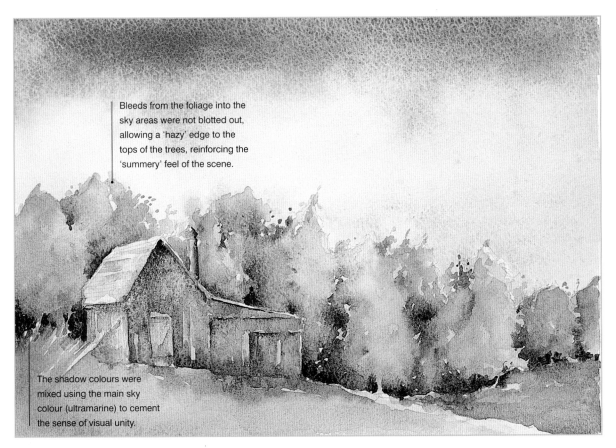

Bleeds from the foliage into the sky areas were not blotted out, allowing a 'hazy' edge to the tops of the trees, reinforcing the 'summery' feel of the scene.

The shadow colours were mixed using the main sky colour (ultramarine) to cement the sense of visual unity.

Winter lakeside

If you develop a liking for painting outdoors, you could challenge yourself by tackling a winter scene. Of course, you always have the option of working from photographs if you want to capture winter's beauty without having to deal with harsh winter weather.

The cool, sharp atmosphere of a mountain lake is a true pleasure to witness. Painting this scene involves making a few choices about the colours you need to use, and these come largely from the cooler end of the colour spectrum – although not exclusively. You usually find a balance in nature where colours and tones harmonize: the warmer tones on the rocks and trees in the middle ground, for example, sit easily with the cooler grey colours of the snow fields of the distant mountains.

Materials

300gsm (140lb) watercolour paper, 1 large (no. 12) brush, 1 medium (no. 8) brush, 1 small (no. 2) brush, 1 chisel-headed brush, kitchen paper, water container, watercolour paints

1 To begin with, dampen the sky area and, using a large brush, apply a wash of Winsor blue and allowed this to flow evenly across the paper. Actively encourage the paint to accumulate at the top of the paper, leaving a lighter section along the ridges of the mountains.

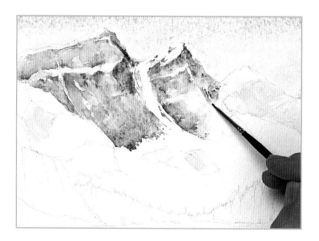

2 Block in the grey tones of the mountains using a mixture of raw umber and Winsor blue on dry paper with a chisel-headed brush. Use a small brush to intensify the stone-grey paint by adding a touch of alizarin crimson.

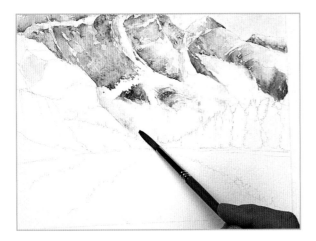

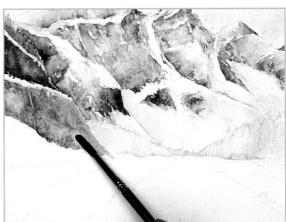

3 The shadows cast onto the snow use a very diluted mixture of alizarin crimson and a touch of Winsor blue. Wash them out at the edges to prevent hard lines occurring. Put a yellow ochre underwash on the middle-groun rocks and trees and leave to dry.

4 Paint the middle-ground rocks using a combination of raw umber and Winsor blue, applied with a medium brush. Pull the colour across the dry paper using broken brushstrokes, allowing the underwash to show through.

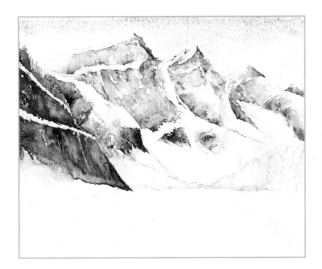

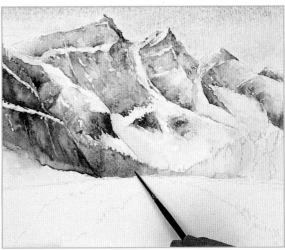

5 Before this mixture has time to dry fully, pull a little of the rock colour down onto the snow directly below to act as a shadow, tonally harmonizing the different aspects of the scene.

6 Mix a little sap green with raw umber and a touch of Winsor blue to create a cold, distant blue/green, and paint it onto the middle-ground trees using a small brush. Blot the top areas with kitchen roll to expose the yellow ochre underwash.

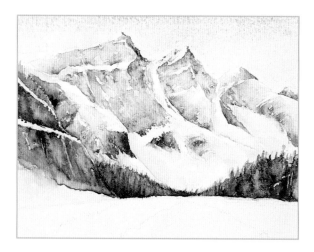

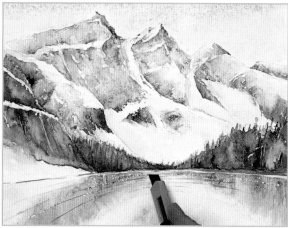

7 This process is continued across the middle ground until the entire section is complete. You can now see clearly which colours you will need to pull down onto the water for the reflections.

8 Using a large brush, dampen the lake area and, using the colours left in your palette, apply the colours (working around the snow field reflections) using vertical brushstrokes.

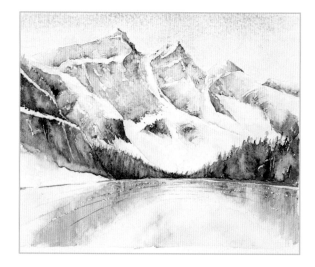

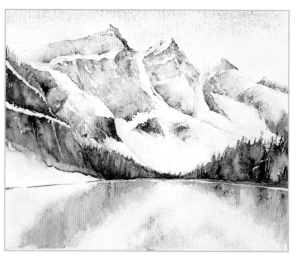

9 When this has dried, take a small brush, mix all the paints together in the palette, and paint on a few thin lines of ripples, moving outwards around the edge of the lake.

10 Once the reflections and ripples have fully dried, scratch out a few areas of sparkle to enhance the effect of light.

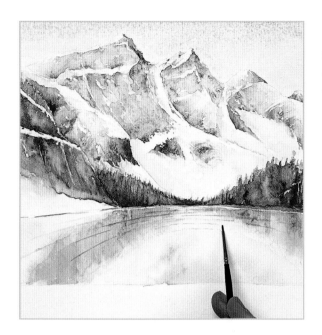

11 The final stage is to sharpen up any edges or shadows that needed reinforcing and to make a final check that all the elements in the composition are visually balanced.

Aim for a balance of all elements in your paintings: the warm and cold colours, and the stillness of the background and the movement in the foreground. Both sit together particularly well in this painting.

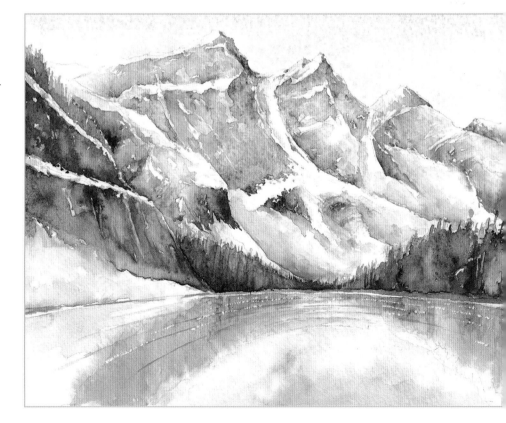

Acknowledgements

The publisher would like to thank Nicola Hodgson, Richard Taylor and Albany Wiseman.

Picture credits

Albany Wiseman: pages 1, 2, 10 (bottom left), 11, 12, 13, 14, 15, 18, 19, 20, 21, 22, 26, 27, 28, 29, 33 (bottom left), 36, 38, 39, 40, 41, 42, 50–53, 56–57, 66, 73, 77, 78, 81, 82 (bottom), 83, 85, 86–87, 90–100, 103–107

Collins and Brown: pages 8, 9, 10 (bottom right), 21, 22, 30, 32, 33 (right), 34, 34, 37, 43, 44, 45, 46 (top), 48, 54–55, 68–69, 70–72, 74, 79, 80, 82 (top), 84, 101, 114–119

Richard Taylor: pages 17, 24–25, 33 (top left), 46 (bottom), 49, 58–65, 75, 76, 88, 106–113, 120–127, 128